STIRLING

THE POSTCARD COLLECTION

JACK GILLON

AMBERLEY

First published 2021

Amberley Publishing
The Hill, Stroud, Gloucestershire, GL5 4EP
www.amberley-books.com

Copyright © Jack Gillon, 2021

The right of Jack Gillon to be identified as the Author
of this work has been asserted in accordance with the
Copyrights, Designs and Patents Act 1988.

ISBN 978 1 3981 0466 2 (print)
ISBN 978 1 3981 0467 9 (ebook)

British Library Cataloguing in Publication Data.
A catalogue record for this book is available from the
British Library.

Origination by Amberley Publishing.
Printed in Great Britain.

CONTENTS

	Introduction	4
SECTION 1	Stirling Castle	6
SECTION 2	The Environs of the Castle	17
SECTION 3	Stirling Streets	28
SECTION 4	Stirling Landmarks	44
SECTION 5	The Valley Cemetery and Church of the Holy Rude	59
SECTION 6	Stirling Bridge	69
SECTION 7	National Wallace Monument	76
SECTION 8	Around Stirling	83

INTRODUCTION

Stirling, like a huge brooch, clasps the Highlands and Lowlands together.

A Summer in Skye, Alexander Smith (1865

Who, does not know Stirling's noble rock, rising, the monarch of the landscape, its majestic and picturesque towers, its splendid plain, its amphitheatre of mountain, and the windings of its marvellous river; and who that has once seen the sun descending here in all the blaze of its beauty beyond the purple hills of the west can ever forget the plain of Stirling, the endless charm of this wonderful scene, the wealth, the splendour, the variety, the majesty of all which here lies between earth and heaven.

The Highlands and Western Isles of Scotland, John Macculloch (1824

Stirling may be the smallest of Scotland's seven cities, but it has a fascinating wealth of architectural and historic heritage that would be the envy of much larger places in the country.

Geography was a critical factor in Stirling's development. Spanning the boundary between the Highlands and Lowlands and standing at the heart of Scotland, it developed as a fortress town at the lowest bridging point over the Forth, which was a vitally strategic crossroads, and the location of the rugged volcanic crag of the Castle Rock.

Stirling's strategic importance as the 'Gateway to the Highlands' also made it the much-fough over 'Cockpit of Scotland' and it has been witness to many of the most significant battles in Scottish history – the Battle of Stirling Bridge (1297), Bannockburn (1314), Sauchieburn (1488 and Sheriffmuir (1715). It was said that to take Stirling was to hold Scotland. It, therefore, comes as no surprise that the name Stirling is derived from 'Striveling', meaning 'place of strife'.

The town developed on the steep tail that runs down from the castle's rocky crag and early settlement prospered under protection of the castle. It was one of the four principal Royal Burghs of Scotland, with a charter that dates from 1226 and a burgh seal from 1296. It was the marketplace for Stirlingshire and much of the rest of the country, and a port from medieval times.

During the thirteenth and fourteenth centuries, the castle and town were razed during the Wars of Independence between England and Scotland – defensive walls were built around the town in 1547. During the fifteenth and sixteenth centuries, the Stuart kings made Stirling their favoured residence and the arrival of the royal court did much to foster the development of the town.

With the exception of the tradition of weaving, much of the Industrial Revolution bypassed Stirling, which contributes to its enduring character. Stirling principally functioned as a market town servicing the surrounding rich agricultural carse lands of the River Forth.

Stirling was also a historic port that supported overseas trade and had a daily steamer service to and from Leith. The advent of the railway in 1848 started the decline of the river trade and by the mid-twentieth century the port had ceased to operate. At the time of writing there are exciting proposals to put the river back at the heart of the city. These include the Forthside development, which has already regenerated part of the riverbank; a river taxi network, with stops connecting key sites; and enhanced riverside walking and cycle paths linking the river with the city centre.

Stirling is central to Scotland and its history, and today it is a charming historic city that retains much of its ancient character and architectural quality. Stirling was granted city status as part of the Queen's Golden Jubilee celebrations on 12 March 2002.

Royal Mail first allowed picture postcards to be sent through the post in 1894. Only the address of the recipient was allowed on the undivided back of the cards, as it was considered unseemly for messages to be openly displayed. In 1902, the first divided-back postcards with space for a message were published. This, combined with increasing levels of literacy, some improvement in holiday entitlement for workers and better public transport resulted in a boom period for the picture postcard, which lasted until the outbreak of the First World War in 1914. A swift mail service with multiple daily deliveries also meant that they were a speedy method of communication – the email of their time. The popularity of picture postcards declined after the First World War with the advent of affordable cameras.

Old picture postcards are an invaluable visual record of a place's past and provide a fascinating insight into the world of our ancestors. The old postcards of Stirling celebrate the town's civic achievements and distinctive character in the form of public buildings, principal streets and historic landmarks.

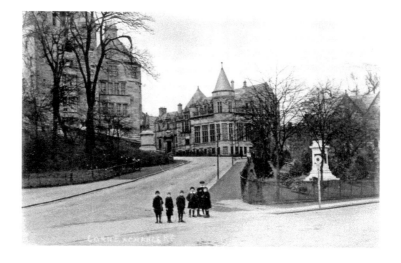

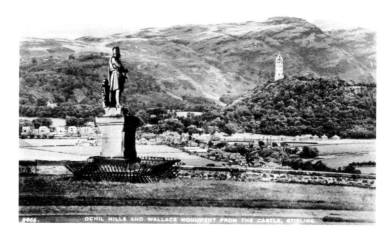

SECTION 1
STIRLING CASTLE

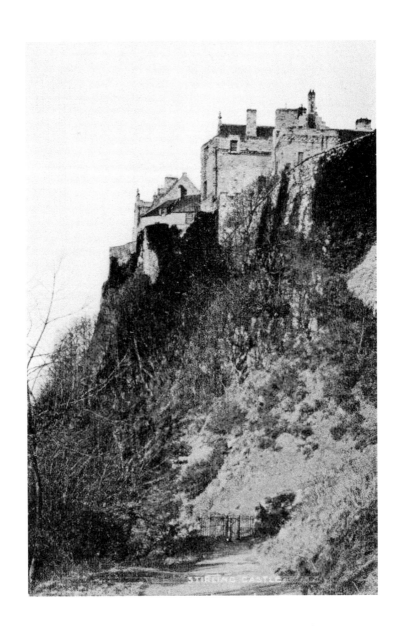

STIRLING CASTLE

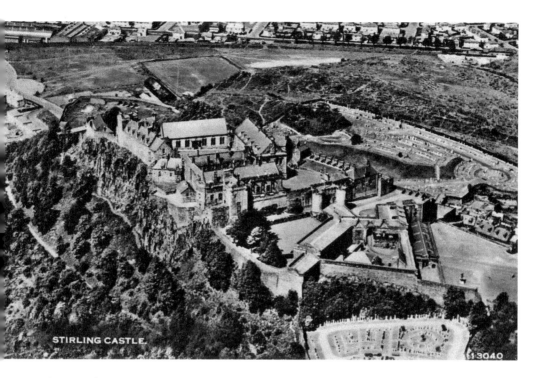

STIRLING CASTLE.

13040

Stirling Castle

The most interesting and important edifice in Stirling is the Castle crowning the precipitous extremity of the ridge on which the town is built and forming the most conspicuous object to the surrounding country.

The Merchants' Guide to Stirling (1897)

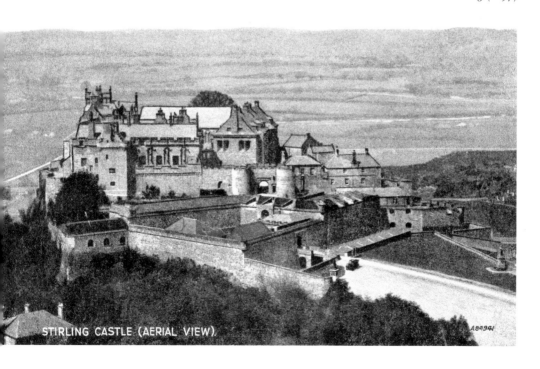

STIRLING CASTLE (AERIAL VIEW).

A88941

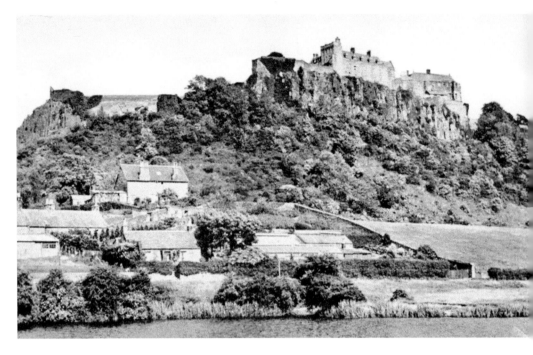

Stirling Castle

Set dramatically on its high crag, Stirling Castle dominates the landscape for miles around. Although there is no clear evidence, it is likely that the naturally defensive site of the castle was a stronghold from prehistoric times. The earliest reference to the castle is in the early twelfth century, when Alexander I endowed a chapel within it. The castle changed hands repeatedly in the wars between Scotland and England.

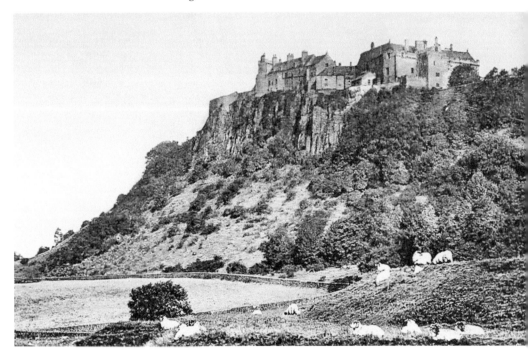

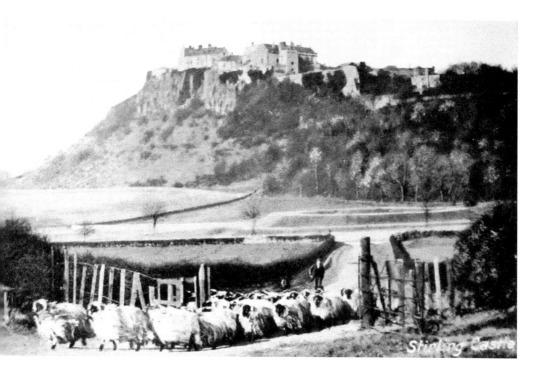

Stirling Castle

Most of today's castle buildings date from the time in the late fifteenth to sixteenth centuries when it was a fortress, royal palace and a favourite residence of the Stuart kings. After the Union of the Crowns in 1603, the Stuarts effectively abandoned the castle as a residence.

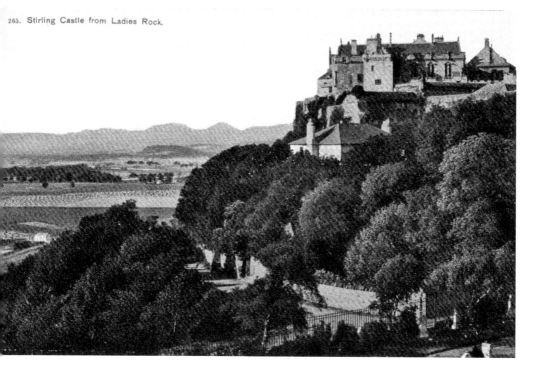

263. Stirling Castle from Ladies Rock.

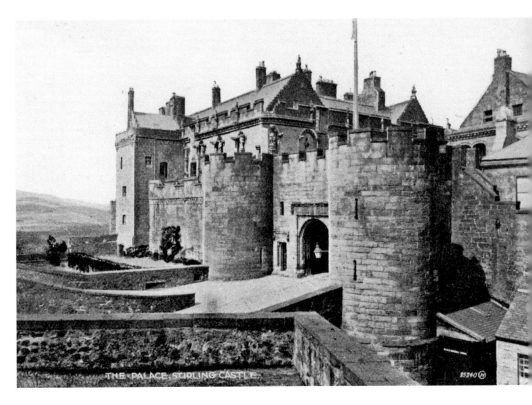

Stirling Castle

The castle was in use as a military base from the late seventeenth century and additional defences were built in 1708 due to the unrest caused by the Jacobite threat. The national importance and tourism potential of Stirling Castle was recognised in the 1960s and a programme of restoration works undertaken. The castle is now one of the most visited tourist sites in Scotland.

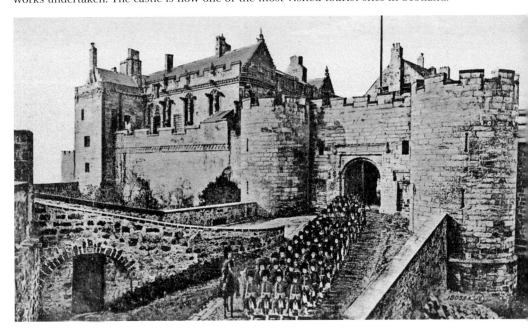

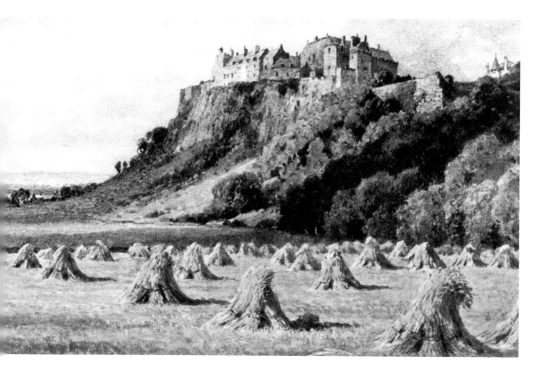

Stirling Castle

The castle is well defended on three sides by steeply sloping rock faces. The approach from the south was more of a soft target and was the most fortified. The present forework dates from around 1506 and was built under the reign of James IV. It originally consisted of six towers with conical roofs, which, along with the guardhouse, were twice as high as at present.

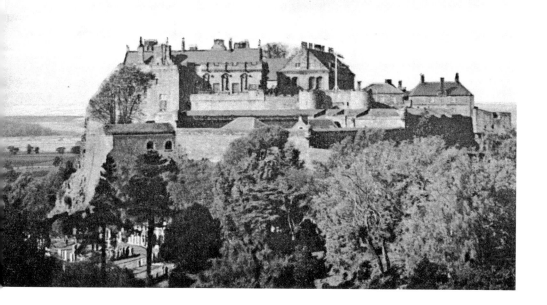

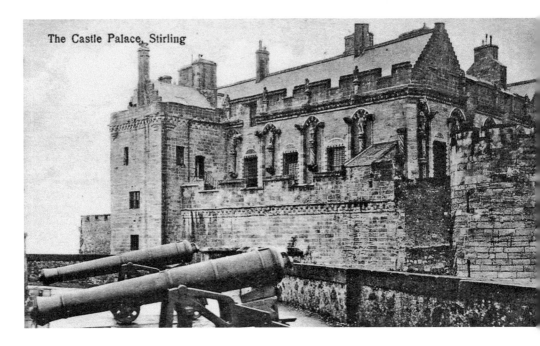

The Castle Palace, Stirling

Royal Palace, Stirling Castle

The Royal Palace at Stirling Castle was built during the latter part of the reign of James V as appropriately prestigious accommodation. Work started in the 1530s and it was mainly complete at the time of James' death in December 1542. The interior originally consisted of an almost symmetrical arrangement of a matched group of rooms of state. Daniel Defoe described them as 'the noblest I ever saw in Europe, both in Height, Length and Breadth'. The rooms were grouped around a paved courtyard known as the Lion's Den – from the heraldic lion of Scotland or possibly from the fact that it housed a real lion. The palace was the childhood home of the young Mary, Queen of Scots.

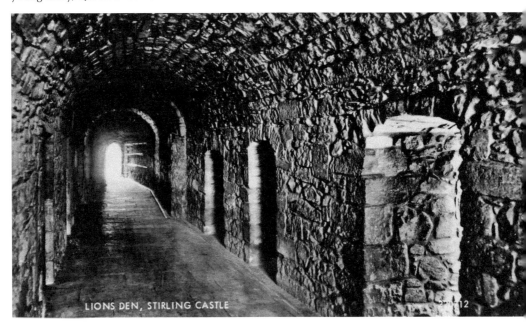

LIONS DEN, STIRLING CASTLE

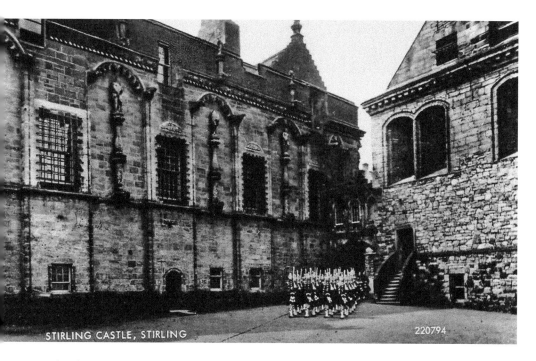

STIRLING CASTLE, STIRLING 220794

Royal Palace, Stirling Castle

The palace continued in use as an important royal residence until the Union of the Crowns in 1603 when the court moved to London and the building lost its main purpose. It was gradually converted for military accommodation in the eighteenth century. After the departure of the army in 1964 the building served as a function room and café. In June 2011, the building opened to the public after a £12 million project to recreate its original splendour.

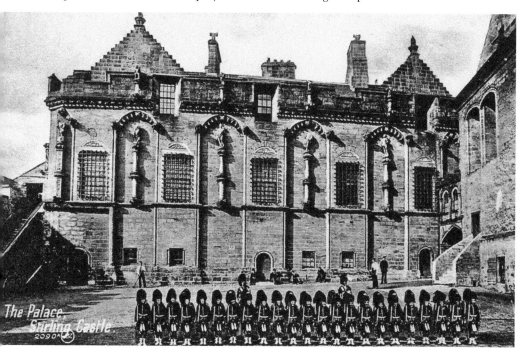

The Palace, Stirling Castle.
2090

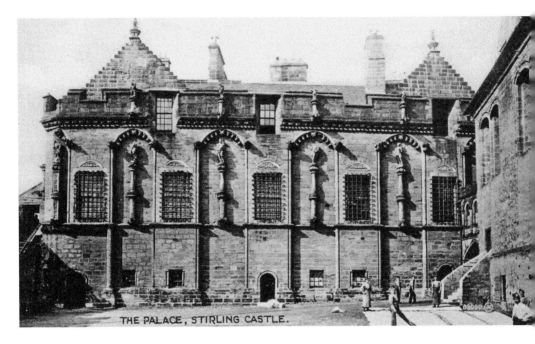

THE PALACE, STIRLING CASTLE.

Royal Palace Statues

The exterior of the palace is festooned with bold carvings that represent a unique collection of Scottish Renaissance sculpture. A devil, grotesque monsters and a line of armed soldiers face the outside. Classical deities and musicians decorate the inner courtyard. James V is depicted in a more natural form with a bushy beard and wearing the Highland dress of the time. They would originally have been painted and gilded and were designed to proclaim the king's importance. R. W. Billings (1813–74), the Victorian architectural historian, described them as 'the fruits of an imagination luxuriant but revolting'.

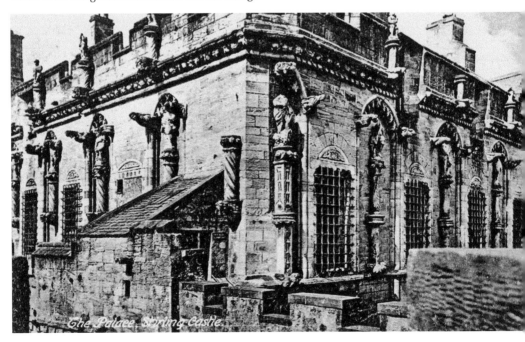

The Palace, Stirling Castle.

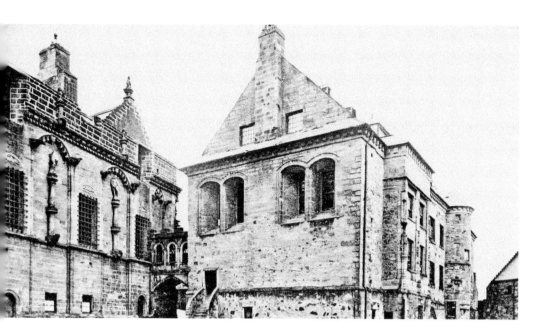

The Great Hall, Stirling Castle

The Great Hall was completed in 1503, in the reign of James IV. It was intended as a magnificent venue for royal occasions and is the largest medieval hall in Scotland. The hall was used for the baptisms of James VI (in 1566) and Prince Henry (in 1594). The banquet following the christening of Prince Henry was a lavish affair, with a huge boat floating in an artificial sea dispensing sweetmeats and equipped with working cannons for a salute to the young prince. The hall was very occasionally used for sittings of Parliament. After the Union of the Crowns in 1603 it was radically adapted by the military. Since the army moved out in the mid-1960s the hall has been the subject of a major restoration scheme. The restored Great Hall was opened by Elizabeth II on 30 November 1999.

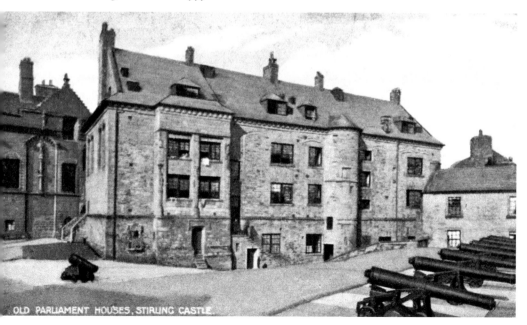

OLD PARLIAMENT HOUSES, STIRLING CASTLE.

15

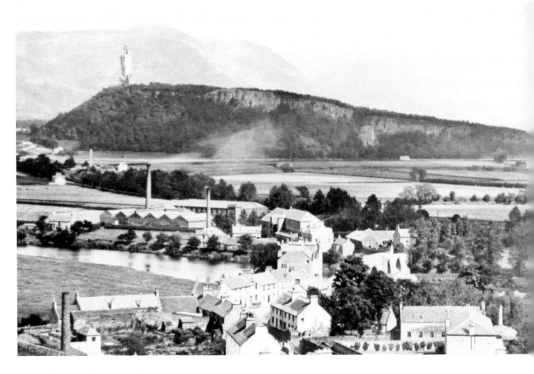

View from Stirling Castle

The view from Stirling Castle is the most beautiful of its kind that is to be seen in the United Kingdom.

In England Wales and Scotland, J. G. Kohl (1844)

It is hard to disagree with Mr Kohl when it comes to this outstanding view to the Abbey Craig and the Wallace Monument with the Ochils in the background. It is 'a picture of natural beauty which is difficult to surpass'.

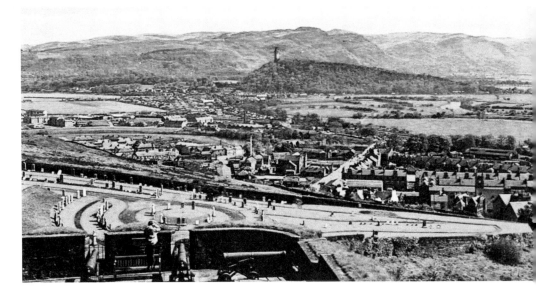

SECTION 2

THE ENVIRONS OF THE CASTLE

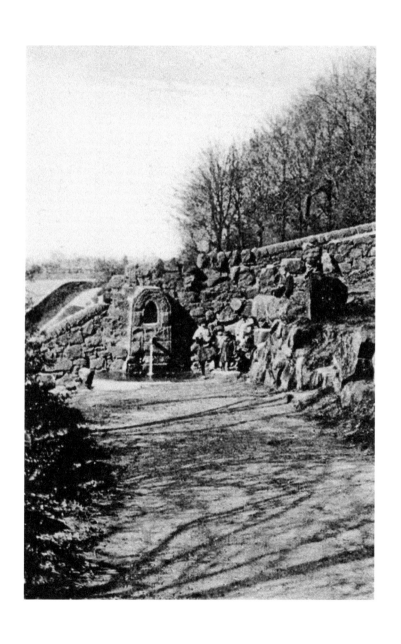

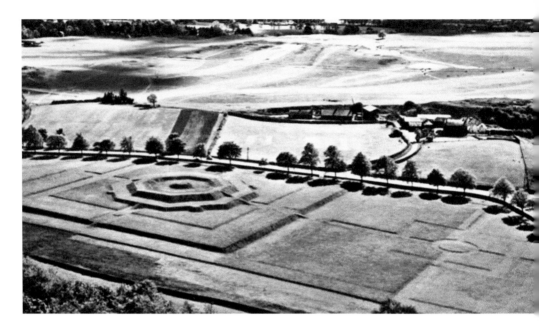

The King's Knot, King's Park

The King's Knot, to the south-west of the castle, within the King's Park, formed part of a magnificent seventeenth-century formal garden. The Knot consists of a concentric, stepped, octagonal mound covered with grass. It originally formed the centrepiece of a surrounding rectangular parterre garden that would have been planted with box trees and ornamental hedges. The King's Knot is known locally as the 'Cup and Saucer'. A smaller, less distinct mound within the gardens is known as the 'Queen's Knot'.

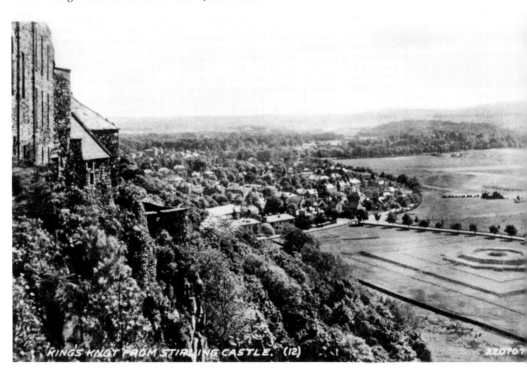

KING'S KNOT FROM STIRLING CASTLE. (12)

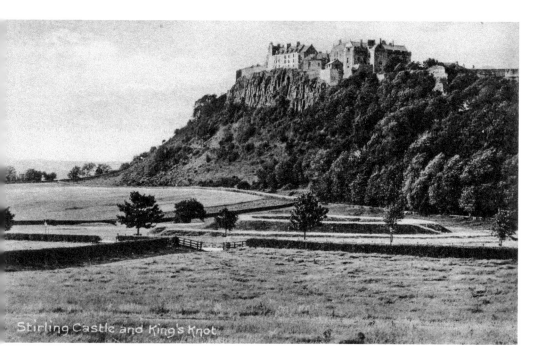

Stirling Castle and King's Knot

The King's Knot, King's Park

The King's Knot is said, by tradition, to have been the scene of some forgotten play or recreation, which the King used to enjoy on that spot with his court. In an earlier age, this strange object seems to have been called the Round Table; and, in all probability, it was the scene of the out-of-door's game of that name, founded upon the history of King Arthur. To give further countenance to this supposition, we have ascertained the fact that James IV, with whom Stirling was a favourite and frequent residence, was excessively fond of the game of the Round Table, which probably appealed, in a peculiar manner, to his courtly and chivalric imagination.

Picture of Stirling, Robert Chambers (1830)

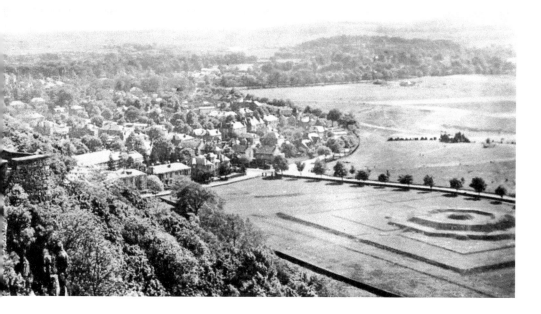

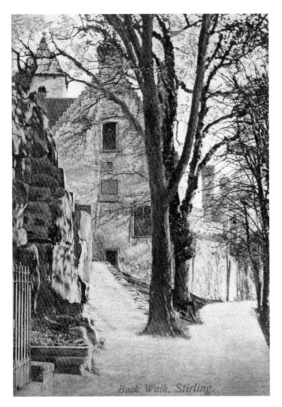

Back Walk, Stirling.

The Back Walk
Devoid of feeling must the mind be, that
does not enjoy the sensations which the
objects to be met with in Edmonstone's
walks are calculated to raise. Let not
any such ascend the craggy wilds round
which this path is conducted, in vain,
to him, doth nature spread forth her
grandeur, in rude, sublime, and fantastic
forms; he feels not their impressive
force: they awaken not in his bosom the
glow of sentiment and association of
ideas whence the mental feast of pure
delight is furnished.

The History of Stirling (1812)

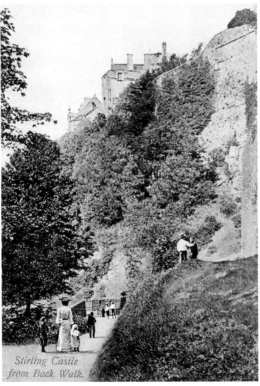

Stirling Castle
from Back Walk.

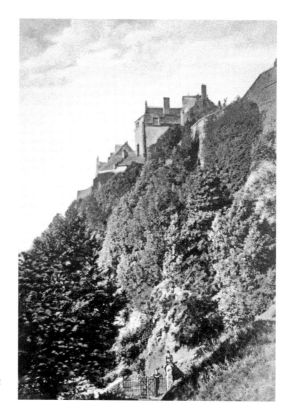

The Back Walk

The Back Walk is a 'fine wooded public airing ground' and follows the historic city walls, providing stunning panoramic vistas of the surrounding area. It was constructed under the patronage of William Edmonstone, the Laird of Cambuswallace. It was originally built in 1724 from the rear of the former High School to Lady Hill and was extended in the 1790s to Dumbarton Road and around the castle to the Gowanhill.

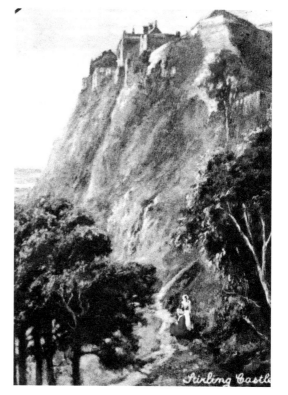

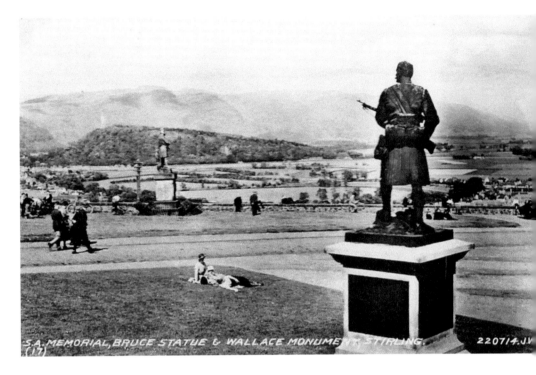

S.A. MEMORIAL, BRUCE STATUE & WALLACE MONUMENT, STIRLING. 22071/4.J.V (17)

Castle Esplanade

The esplanade in front of the castle entrance was built in 1812 and was used as a parade ground, and now as a car park and performance space. It 'commands magnificent views of some of the fairest and most historic scenes in Scotland'. The Bruce Monument and South African War Memorial are prominent features on the esplanade.

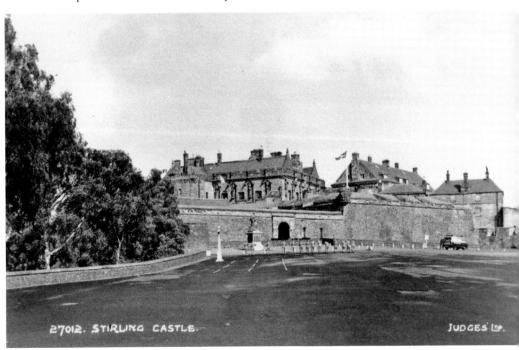

27012. STIRLING CASTLE. JUDGES Lᵗᵈ.

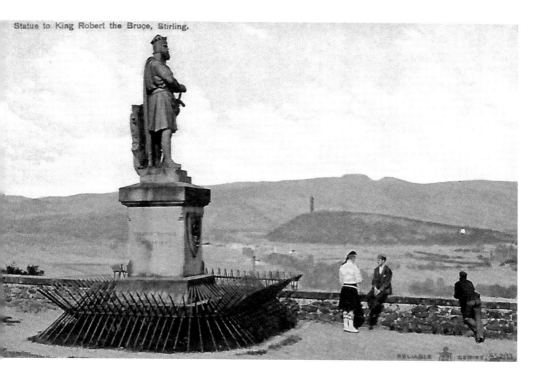

Statue to King Robert the Bruce, Stirling.

The Bruce Monument, Castle Esplanade

The massive 11-foot-high (3.3-metre) statue of Robert the Bruce on the castle esplanade depicts the warrior king looking towards Bannockburn and sheathing his sword in 'the moment of victory'. The inscription on the monument reads: 'King Robert the Bruce: June 24th, 1314' – the date of the Battle of Bannockburn.

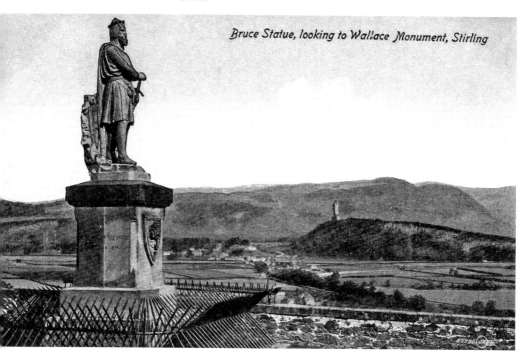

Bruce Statue, looking to Wallace Monument, Stirling

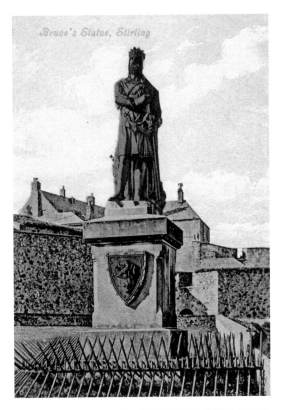

Bruce's Statue, Stirling

The Bruce Monument, Castle Esplanade
The statue of Robert the Bruce was paid for by public subscription, sculpted by Andrew Currie (1812–91) and unveiled on 24 November 1877 by Lady Alexander of Westerton in the presence of dignitaries, Scottish regiments and an immense crowd of spectators. When the statue was unveiled, 'the hero of Bannockburn stood out in bold relief, the face expressing conscious dignity, and the whole figure manly bearing and great courage. The vast assemblage burst into loud cheers, which were followed by a royal salute of cannon from the ramparts of the Castle'.

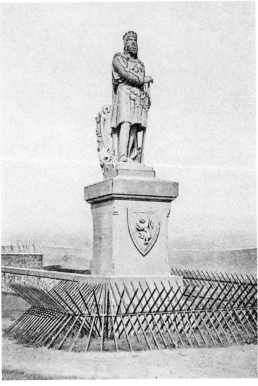

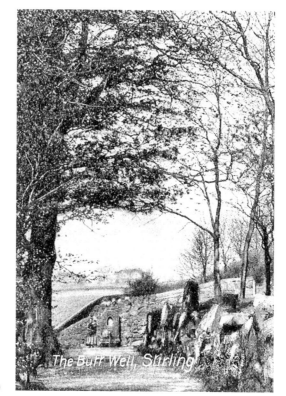

The Butt Well, Butt Park

The Well formed the termination of the early morning walk of the town's folk for a draught of its cold water and was at a late period used by the wives and washerwomen of Stirling for washing their clothes, which were then bleached on the green sward lying below the Well.

Old Nooks of Stirling, J. S. Fleming (1898)

Butt Park takes its name from the area's historic use as an archery shooting ground. The Butt Well was fed by a natural spring and has its origins in the sixteenth century, when it was known as the Spout Well. It was used for watering horses and was the source of the ornamental waters and fountains of the King's Knot. The present wellhead dates from 1842.

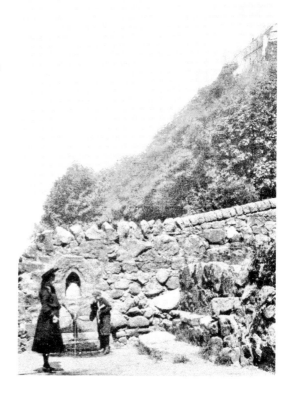

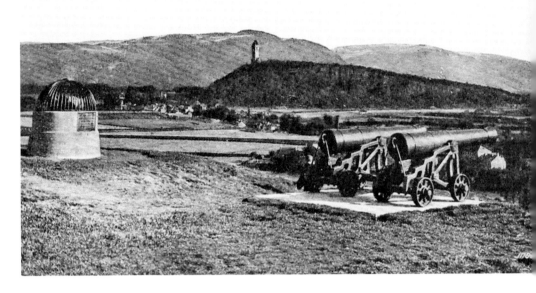

Mote Hill

Mote Hill is the northern section of the Gowanhills part of the royal park around Stirling Castle. It was known locally as 'Hurly-haaky' (or 'Hurly-hawky'), which is derived from a local pastime that involved sliding down the hill on a cow's head skeleton. The two cannons were purchased by the town council from the army at Stirling Castle and moved to the hill for decorative purposes. The main feature on the hill is the beheading stone.

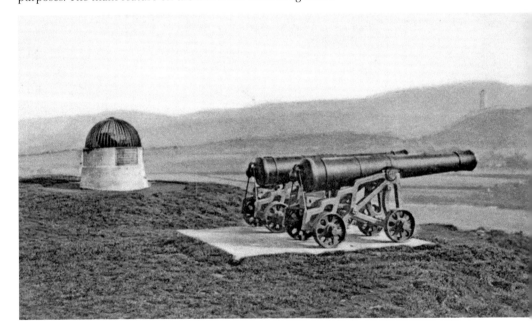

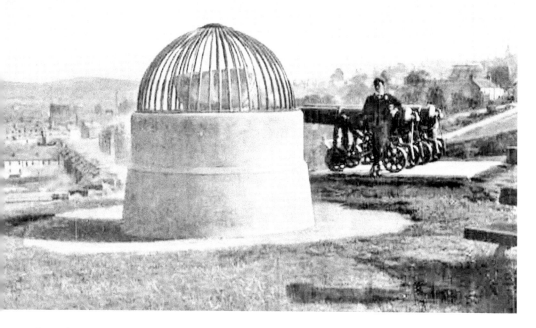

The Beheading Stone, Mote Hill

The beheading stone on Mote Hill was used for capital punishments in the fifteenth century. It is circular with several holes to hold the wooden beheading block. 'Heiding Hill', the alternative name for Mote Hill, alludes to the grizzly use of the site. The stone was used in the execution of some notable people including the Duke of Albany, his second son (Alexander) and his father-in-law, the Earl of Lennox, in 1424. Sir Robert Graham and some of his associates in the assassination of James I were also executed in 1437 on Heiding Hill. The stone is now on a concrete base and is protected by an iron grille, but the axe marks from executions are still visible.

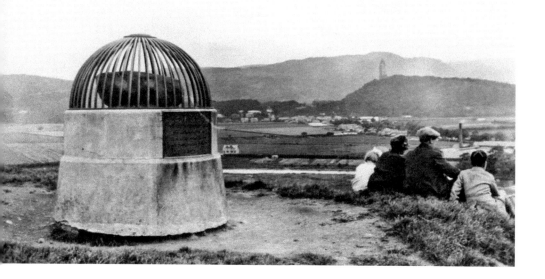

SECTION 3
STIRLING STREETS

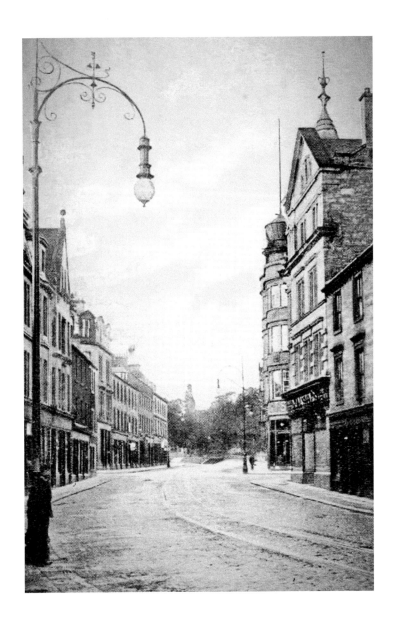

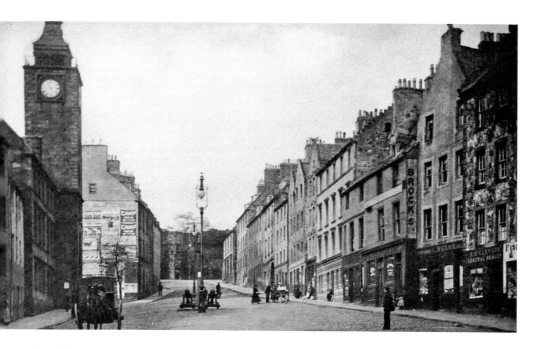

Broad Street

Broad Street, anciently named Hiegait, and afterwards High Street, was once the market and chief place of business. Here were the Tolbooth, the Mercat Cross and the Tron. It was here also the weekly markets and annual fairs were held, stances being allotted to the various trades, whose wares were exposed on staiks or stalls. During the sixteenth century, this spacious street contained the ludgings, or mansions, of the noblemen and Church dignitaries attached to the Court during the Royal residence in the Castle. The principal municipal officials had also their residences in the street.

Merchants' Guide to Stirling (1897)

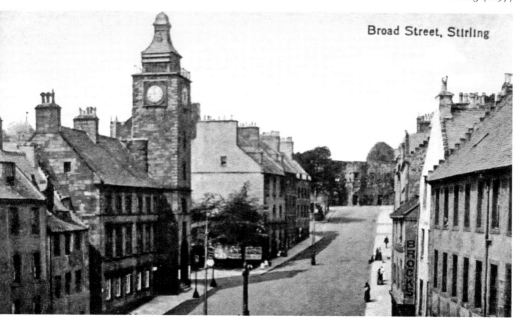

Broad Street, Stirling

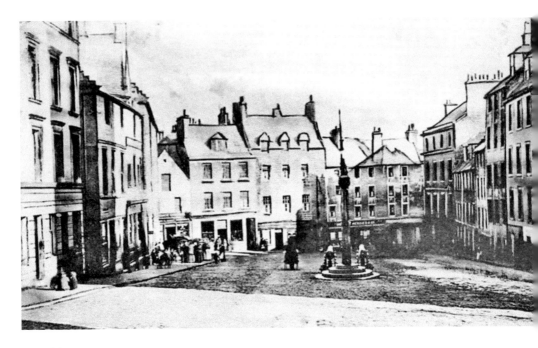

Broad Street

In 1792, Stirling's Mercat Cross was removed from a central position on Broad Street to ease traffic movement. It was reinstated and was unveiled on 23 May 1891, which 'evoked much interest and enthusiasm for the community at large'. It consists of an octagonal shaft on a stepped circular base and is surmounted by a unicorn known as 'the Puggy'. Only the Puggy dates from the original sixteenth-century Mercat Cross. The arrival of the railway in 1848 was an incentive for development closer to the station, which drew commercial activity away from the top of the town. By the early twentieth century Broad Street needed improvement, with many of the buildings in a seriously dilapidated condition.

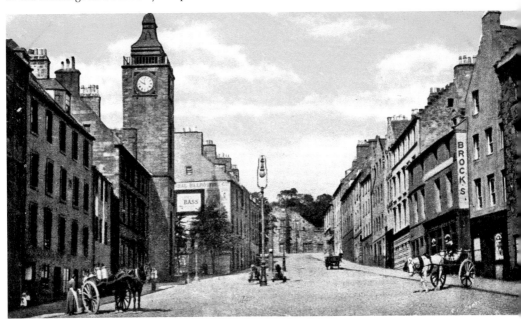

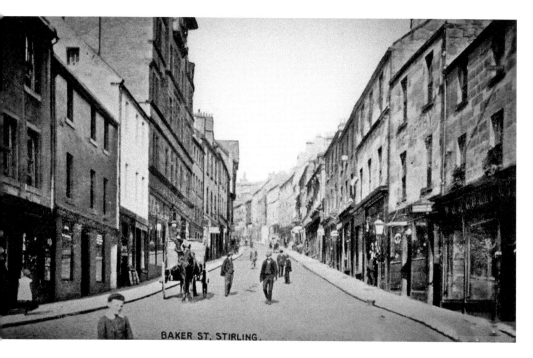

BAKER ST. STIRLING.

Baker Street

Baker Street was previously called Baxter's Wynd. It was the main road through Stirling (reflected in the number of closely packed shops) prior to the development of Murray Place in 1842. The street was the subject of a substantial amount of sensitive reconstruction from the 1930s in a sympathetic traditional vernacular style by architect Sir Frank Mears (1880–1953), who was planning consultant to the burgh.

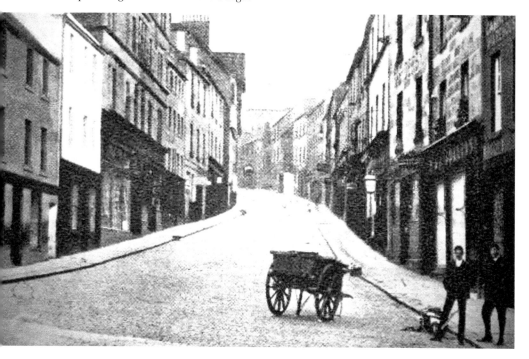

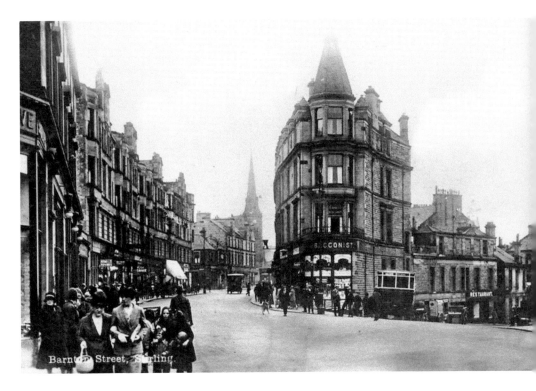

Barnton Street and Maxwell Street

Barnton Street is named for Ramsay of Barnton and Sauchie. The slender spire of Viewfield Church is prominent in the distance on Barnton Street.

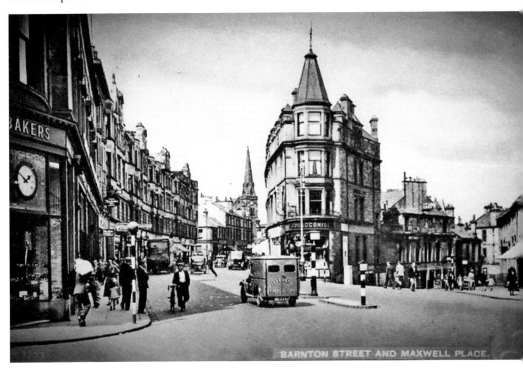

Murray Place

Murray Place was originally a narrow lane leading to orchards around the site of the railway station. It was developed in 1842 to connect King Street to the new bridge over the Forth and to reduce traffic through the upper part of the town. It was named for William Murray of Touchadam & Polmaise (1773–1847), who was the lieutenant-colonel of the Stirlingshire Yeomanry in 1843 and influential in the formation of the new street. Maxwell Place was also named for his wife, Anne Maxwell (1799–1846). Murray Place became commercially more important when the railway arrived in 1848. It remains a prosperous street lined with substantial Victorian buildings.

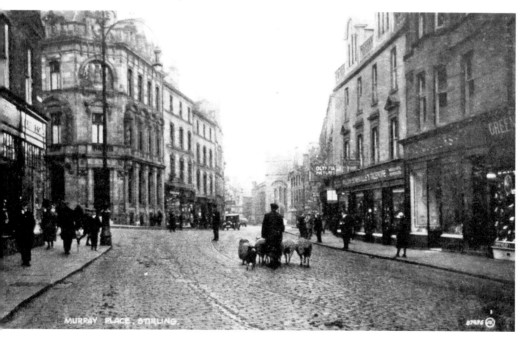

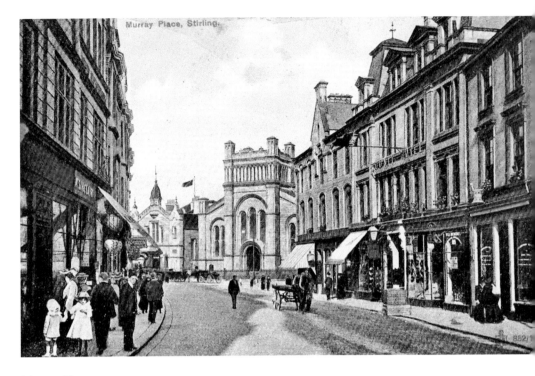

Murray Place

The construction of the Thistles Centre in the early 1970s resulted in significant alterations to Murray Place, including the loss of the Norman-style North Parish Church, which dated from 1843, with its low and massive square tower and the Gothic Revival-fronted Baptist Chapel of 1854. The Olympia Halls first opened in 1909 as a roller-skating rink and was converted to a 'Picture Palace' in 1911.

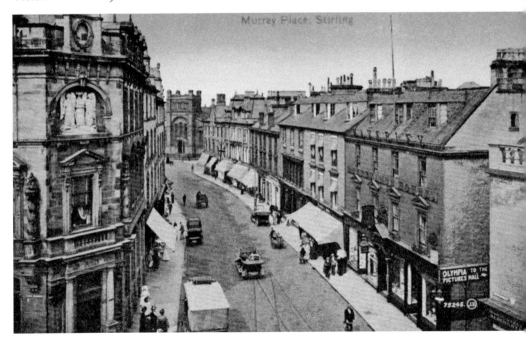

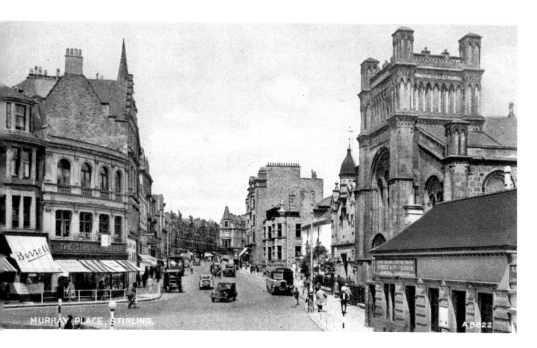

Murray Place

The Stirling Arcade is a prominent feature on Murray Place. It is one of only five shopping arcades in Scotland. It was built between 1881 and 1882 for William Crawford, a Stirling merchant and town councillor. The arcade links Murray Place to King Street and originally contained: two hotels (the Douglas in Murray Place and the Temperance in King Street); a theatre (later a cinema), which hosted many renowned variety performers; thirty-nine shops; and several residential flats. It remains an important historic asset and a unique shopping environment.

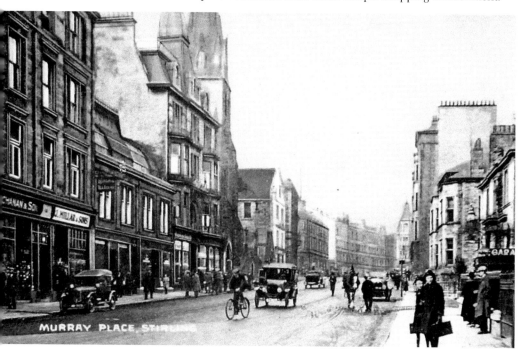

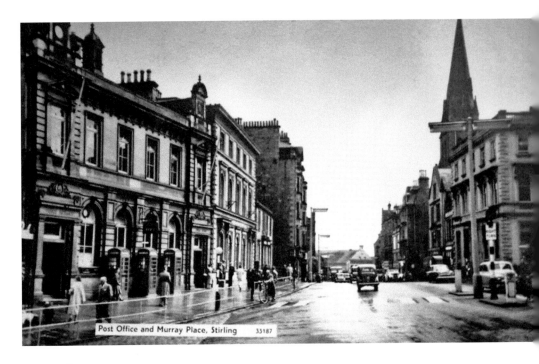

Post Office and Murray Place, Stirling 33187

Murray Place

The building in the left foreground of the postcard images was built as the new post office, which first opened for business on 24 May 1895. The building next to the post office was the National Bank of Scotland, which dates from 1855. A church and monastery, which were founded by Alexander II in 1233, was located around the site of the bank and is commemorated in the street name Friars Wynd.

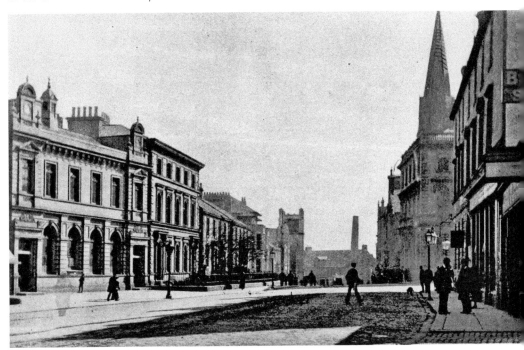

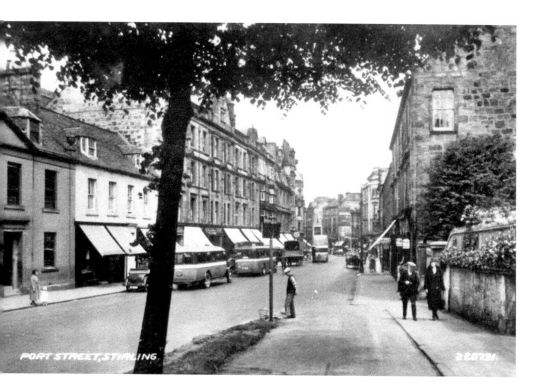

Port Street

Port Street takes its name from the Barras Yett, the main burgh gate, which was the principal entrance to Stirling from the south in the days of the town wall. It was located at the junction of Port Street and Dumbarton Road and is marked by a brass plaque on the pavement.

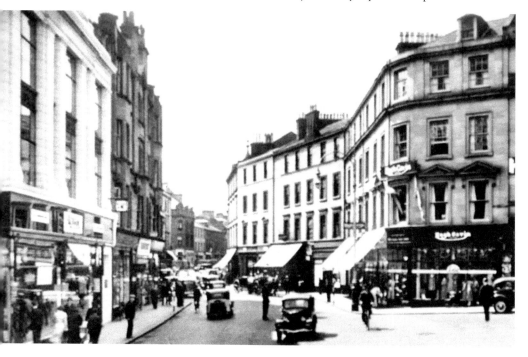

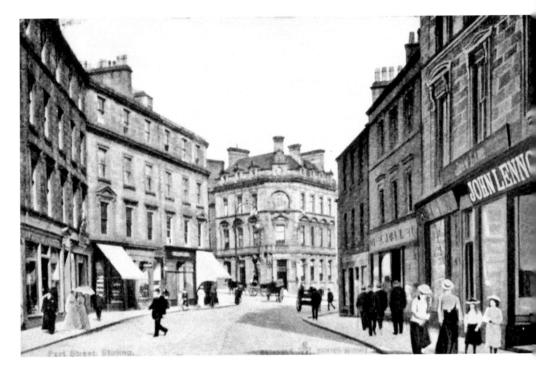

Port Street

Port Street was the main entry point for traffic from the south. The historic route through the town then passed into King Street before ascending Spittal Street and Bow Street to the bottom of Broad Street. It then descended by St Mary's Wynd towards Stirling Old Bridge. The demolition of the Barras Yett in 1770 allowed the development of new streets – Port Street, Murray Place and Barnton Street – at the edge of the old burgh.

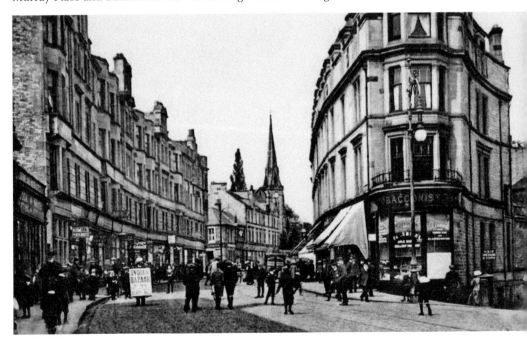

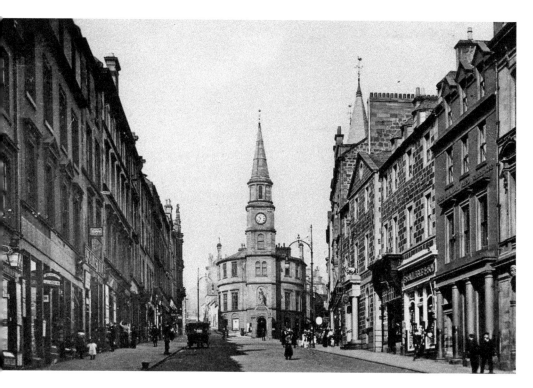

King Street

King Street was part of the old Hie Gait or High Street of Stirling. In 1820, the name Quality Street was changed to King Street upon the coronation of George IV. The location of the New Port, one of the burgh gates, is marked on the roadway outside the Golden Lion Hotel.

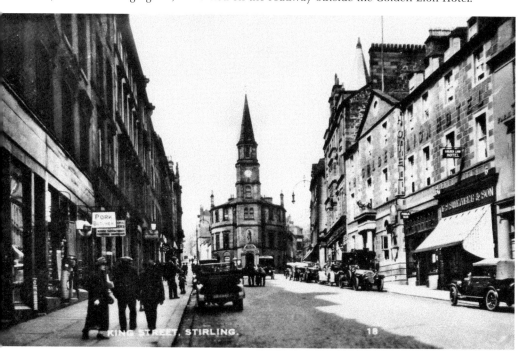

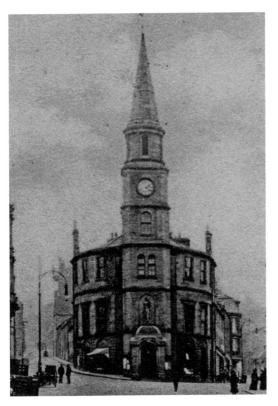

Athenaeum, King Street
The building with the Gothic Revival spire at the head of King Street opened on 17 January 1818. The first floor was occupied by the Stirling Subscription Reading Room and the upper floor by the Stirling Library. The ground-floor shops were initially occupied by Patrick Connal, a merchant; Miss Fletcher, a haberdasher; and Drummond & Sons, seedsmen. A & J Moffat, drapers, were later long-time occupiers of the shops. The building was known rather grandly as the Athenaeum, from the Latin for 'a place of learning'; it is more widely known locally as 'the Steeple'.

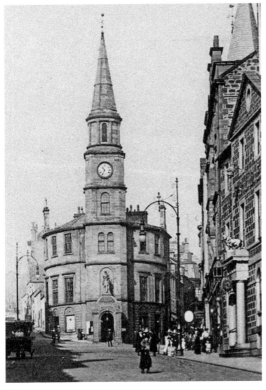

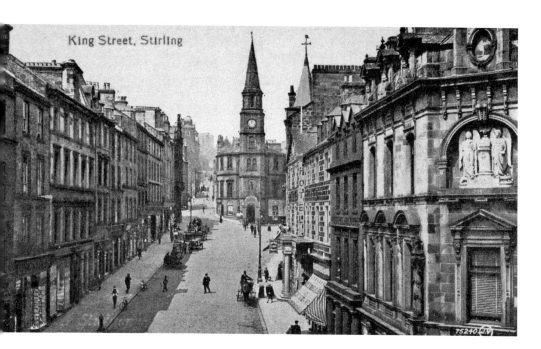

King Street

The building on the right at the foot of King Street was erected for the Stirling Tract Enterprise by Peter Drummond in 1862. Peter Drummond (1799–1877), a Stirling seed merchant, was a particularly devout individual. He established the Stirling Tract Enterprise in 1848 after publishing a religious tract railing against what he considered to be the blasphemous operation of the Cambuskenneth Ferry on the Sabbath. It became the foremost nineteenth-century publisher of religious pamphlets. The building was originally decorated with two angelic figures in the corner niche of the upper floor and the busts of John Knox, Marin Luther and other religious figures. The building was used as a branch of the British Linen Bank when the increase in the Tract Enterprise's business made a move to larger premises necessary.

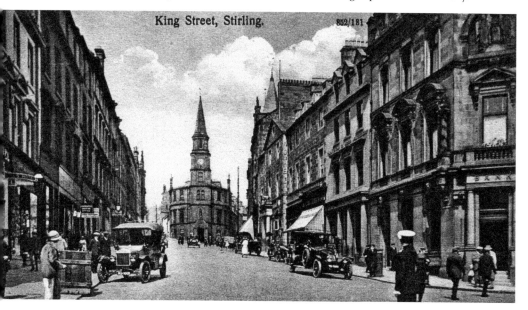

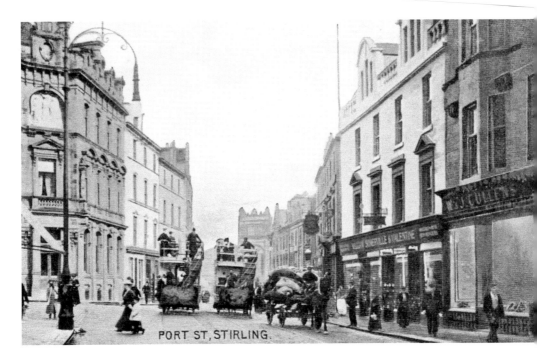

PORT ST, STIRLING.

Stirling Trams

These vintage postcard images show trams on Pont Street and the Bridge of Allan tram terminus. The Stirling and Bridge of Allan Tramway opened on 27 July 1874 with a single line between Port Street and Henderson Street in Bridge of Allan. This was extended on 29 January 1898 with a service from King Street to St Ninians. There were several failed attempts to electrify and expand the routes before Stirling's tram service ended on 20 May 1920.

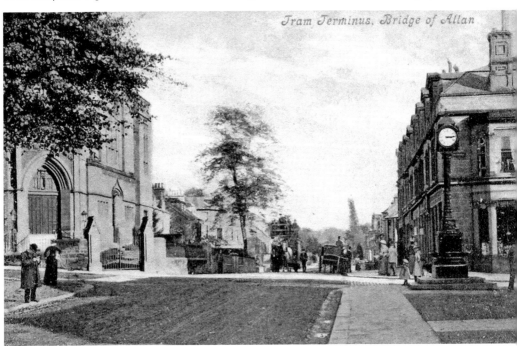

Tram Terminus, Bridge of Allan

Causewayhead

Causewayhead developed around the junction that links Stirling with Bridge of Allan, the Hillfoots and Alloa. The name relates to its location at the head of a mile-long causeway that crossed the marsh to the north of Stirling Old Bridge. The monument depicting a plane on a stone cairn at the Causewayhead roundabout was unveiled in 2005 to commemorate the achievements of Stirling's very own aviation pioneers, Harold (1878–1917) and Frank Barnwell (1880–1938). The Barnwell brothers opened the Grampian Motor & Engineering Company in 1906, near the site of the monument in Causewayhead. On 28 July 1909, their biplane, piloted by Harold and powered by a car engine, flew 80 yards (75 metres) over a field at Causewayhead before it crashed. This flight is recognised as the first powered flight in Scotland, some six years after the historic flight by the Wright Brothers.

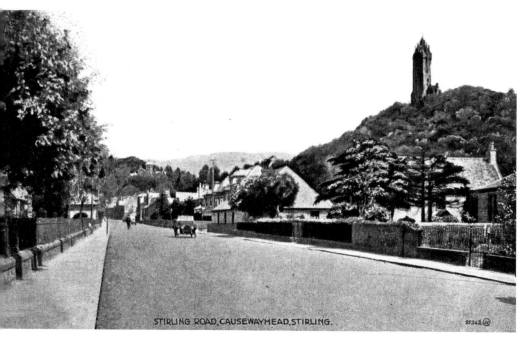

STIRLING ROAD, CAUSEWAYHEAD, STIRLING.

SECTION 4
STIRLING LANDMARKS

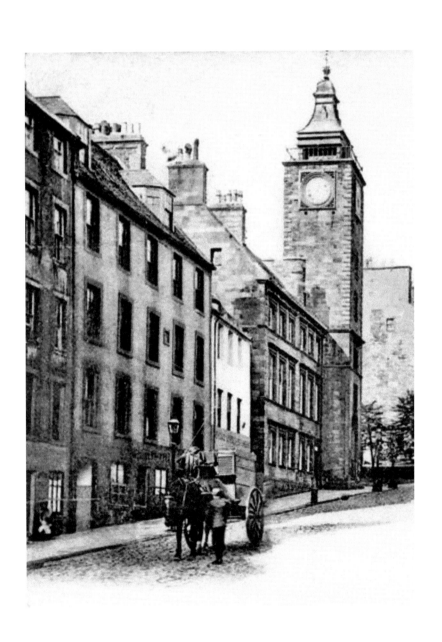

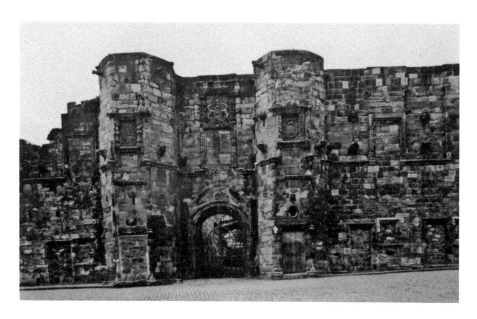

Mar's Wark, Castle Wynd

Part of the elaborate front façade of Mar's Work, which dominates the top of Broad Street, is all that remains of the once splendid town mansion of John Erskine, Earl of Mar. Mar's Wark, or 'Lodging', was commissioned in around 1569 by the influential Erskine, hereditary Keeper of Stirling Castle and one-time Regent of Scotland. The façade features an abundance of sculptures. A number of humorous rhyming inscriptions are also included:

I pray all luikaris on this luging, With gentile E to gif thair juging. I pray all lookers on this lodging, with gentle eye to give their judging.
The moir I stand on oppin hitht. My faultis moir subject ar to sitht. The more I stand on open height, My faults more subject are to sight. (I am conspicuous, so my mistakes are more apparent.)

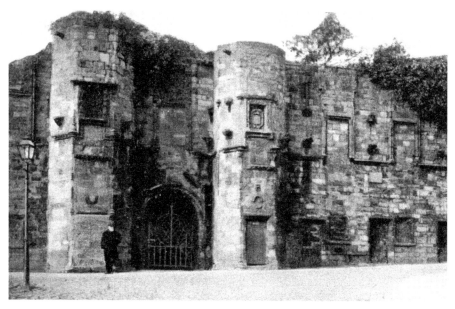

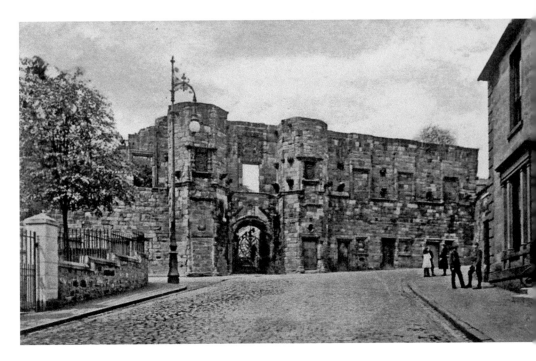

Mar's Wark, Castle Wynd

Mar's Work was converted into barracks after the 1715 Jacobite rebellion and was badly damaged during the 1746 siege of the castle. The building ended its life rather ignominiously as the town's workhouse. The 'Lodging' itself was subsequently used as a quarry for other building projects. It is said that the only reason that it survived in any form was because it sheltered the marketplace from the winds whistling down Broad Street.

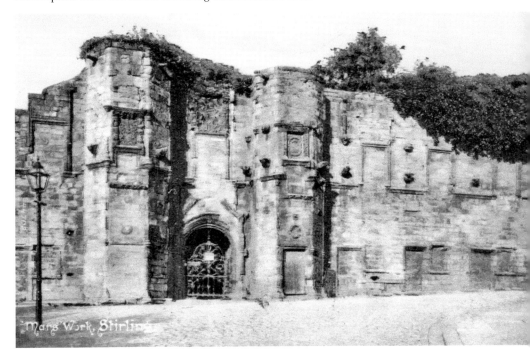

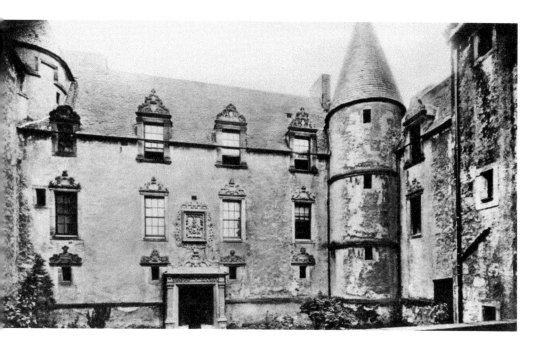

Argyll's Lodging, Castle Wynd

Argyll's Lodging is the most important and complete surviving seventeenth-century town house in Scotland. The Lodging was developed from a small sixteenth-century house in several phases and by several owners. In 1629, Sir William Alexander was the new owner and had the house enlarged and remodelled. Archibald Campbell then bought the house and made significant enlargements and alterations – the courtyard was enclosed behind a screen wall and an elaborate entrance gate installed. In 1764, the 4th Duke of Argyll sold the house and it remained in domestic use until 1800 when it was purchased by the army for use as a military hospital. It became a youth hostel in 1964. In 1996, it was restored to its former historic splendour and opened as a museum.

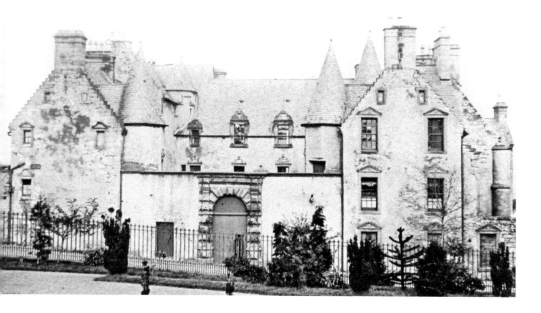

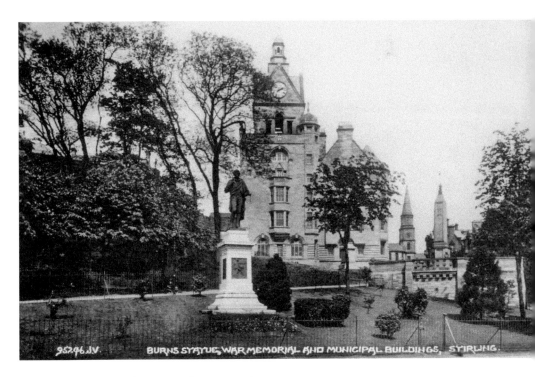

Stirling War Memorial, Corn Exchange Road

The Stirling War Memorial stands in a prominent position beside the municipal buildings and the statue of Robert Burns. The memorial was designed by Stirling architect George R. Davidson and was unveiled on 14 October 1922 by Field Marshall Earl Haig. It consists of a square column in a walled enclosure topped by a flagpole with bronze wreaths on each side and two lions holding a crown. It is a fittingly prominent memorial to the 711 men of Stirling who gave their lives in the First World War and 211 in the Second World War. The memorial was restored in 2014.

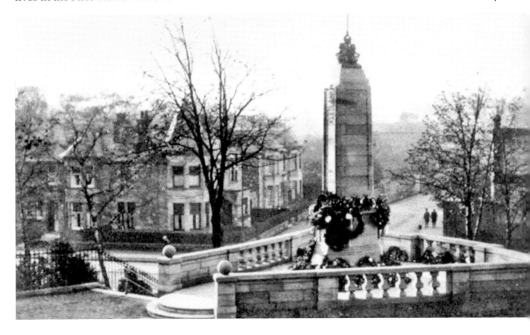

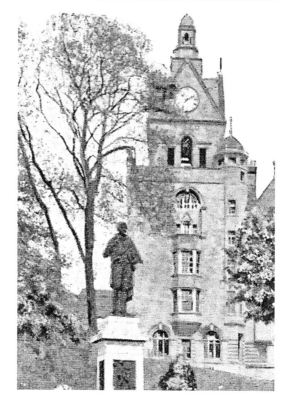

Burns Statue

Robert Burns (1759–96), the National Bard of Scotland, is depicted in more statues around the world than any other literary figure. Stirling's bronze statue of Burns by Albert H. Hodge was gifted by Provost Bayne and was unveiled on 23 September 1914 by his daughter. During a visit to Stirling in August 1787, Burns wrote, 'Just now, from Stirling Castle, I have seen by the setting sun the glorious prospect of the windings of Forth through the rich carse of Stirling.'

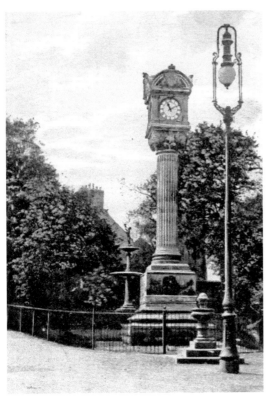

George Christie Memorial Clock, Allan Park

The Christie Memorial Clock was unveiled in 1906. George Christie (1826–1904) was a well-known businessman in Stirling who was provost between 1870 and 1879. In 1905, there were reports of human skulls being uncovered during the excavations for the installation of the clock. The presence of the human remains was accounted for by the fact that the ground was Stirling's seventeenth-century site of public execution and burial – 'the Gallous Mailing'.

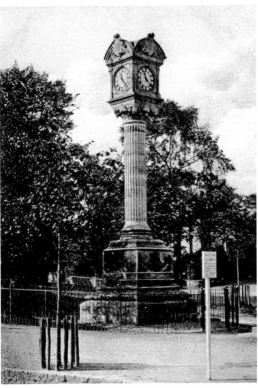

The Black Boy Fountain, Allan Park
The distinctive Black Boy Fountain
was erected in 1849 to commemorate
the outbreak of bubonic plague in the
town in 1360, which, in the cramped
conditions within the city walls, killed
a third of the population at the time.
The fountain was manufactured by
the Neilson Foundry of Glasgow
and was restored in 1997 by the
Ballantine Ironworks of Bo'ness as
part of a regeneration project
for Stirling town centre.

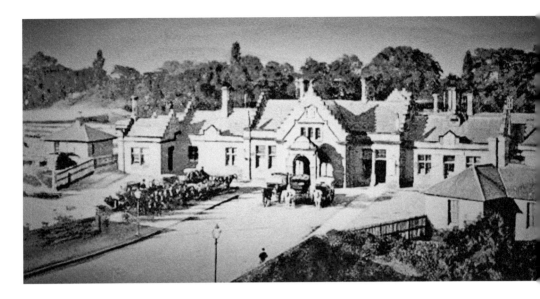

Stirling Railway Station, Goosecroft Road

Stirling was a historic port that supported overseas trade and had a daily steamer service to and from Leith. The railway, which first came to Stirling in 1848, started the decline of the river trade and by the mid-twentieth century the port had ceased to operate. The present railway station building in Stirling, with its picturesque battlements and crow-stepped gables, opened in 1916 following a major rebuild by the Caledonian Railway. It is one of the finest station buildings in Scotland and was designed by the architect James Miller, who is notable for the quality of his Scottish railway stations. The railway made commuting easier and resulted in a substantial expansion of the town.

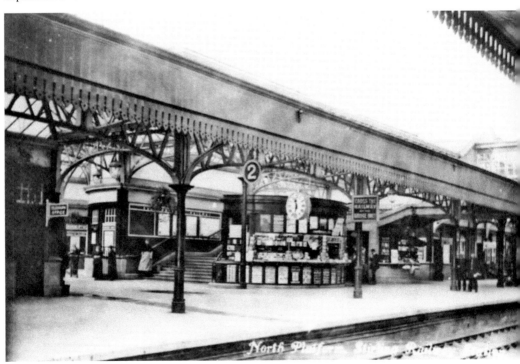

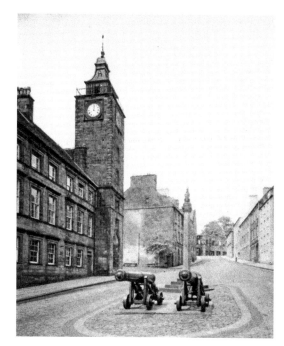

Stirling Tolbooth

The original Tolbooth was erected around 1473 and was partially rebuilt in 1563 due to its dangerous condition. It was taken down and rebuilt, with the addition of the steeple, in 1703–05 according to 'ane drauglit or sceme' prepared by Sir William Bruce of Kinross. The street at the front of the Tolbooth was one of the places where wrongdoers were executed or otherwise punished. The Tolbooth was adapted as a gallery and venue in 2001.

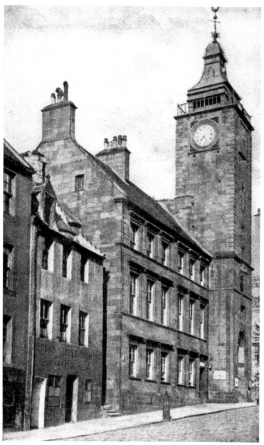

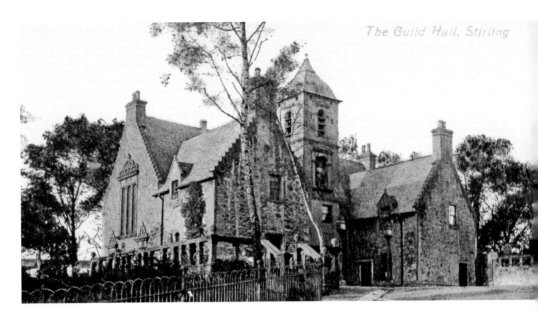

Cowane's Hospital, The Guildhall, St John's Street

John Cowan, a merchant in Stirling, between the years 1633 and 1637, left forty thousand merks, to endow a hospital, or alms-house, for twelve decayed brethren of the guild or mercantile corporation of Stirling. The money was invested in the purchase of lands, which now yield a revenue of upwards of £3,400 sterling per annum. From this fund about a hundred and forty persons, at present, receive relief. The front of the house exhibits a full-length statue of the founder, which will be looked upon with interest as a memorial of the costume of the better order of Scottish burghers, in the reign of Charles I.

A Picture of Stirling, Chambers (1830)

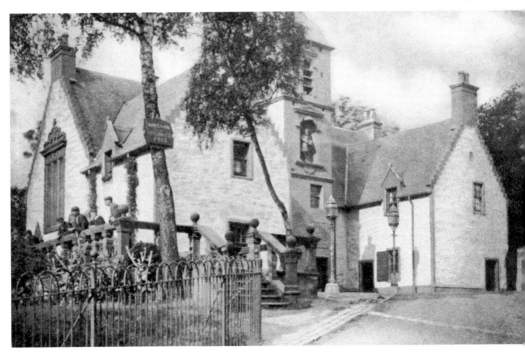

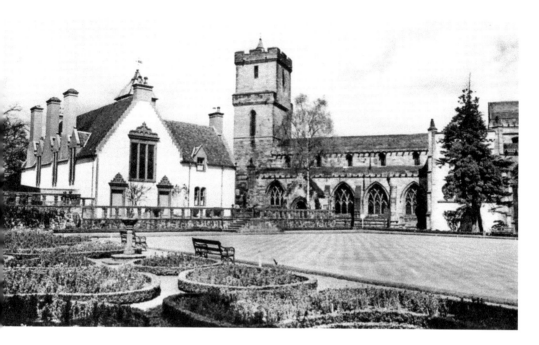

Cowane's Hospital, The Guildhall, St John's Street

The distinctive Cowane's Hospital was built between 1637 and 1648 as an almshouse for destitute members of the merchant guild. It was funded by a bequest in the will of John Cowane (1570–1633), a prosperous Stirling merchant. In 1852, the building was reconstructed as a Guildhall. In the 1660s, the grounds were laid out with ornamental gardens and, in 1712, Thomas Harlaw, gardener to the Earl of Mar, laid out a bowling green, which is one of the oldest in Scotland. The cannons in the grounds were captured at Sebastopol during the Crimean War. At the time of writing the building is closed due to deterioration of the building fabric; however, Heritage Lottery funding has been allocated for repairs and conversion into a visitor attraction.

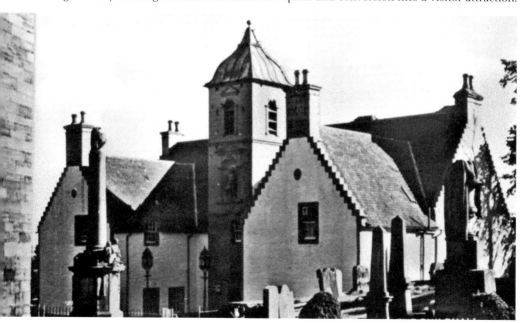

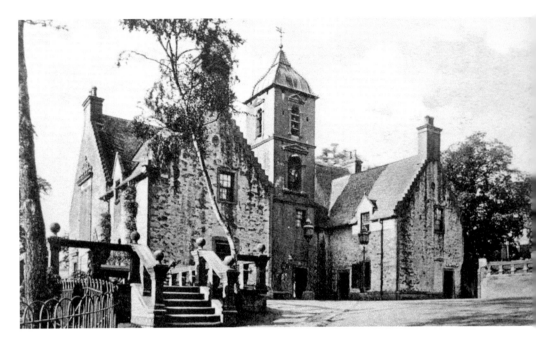

Cowane's Hospital, The Guildhall, St John's Street

Over the entrance to the Guildhall is a niche with a statue of John Cowane and the inscriptions 'This Hospital was erected and largely provyded by John Cowane, Deane of Gild, for the Entertainment of Decayed Gild Breither. John Cowane, 1639', and 'I was hungrie and ye gave me meate, I was thirstie and ye gave me drinke, I was a stranger and ye tooke me in, naked and ye clothed me, I was sicke and ye visited me. Matt. XXV. 35'. The statue of John Cowane is known as 'Auld Staneybreeks' ('old stone trousers'). There is a local legend that every Hogmanay Auld Staneybreeks gets down for a dance in the courtyard.

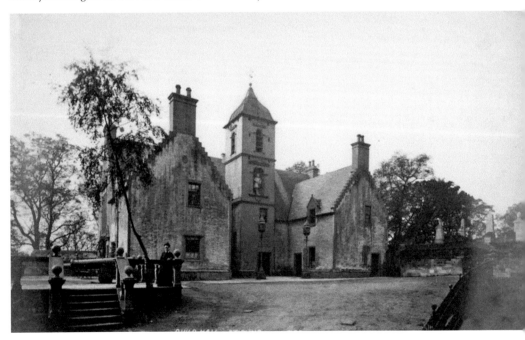

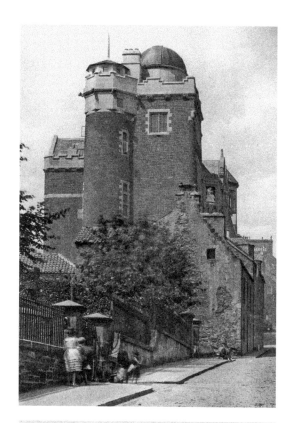

The Old High School, Spittal Street/Academy Road

The Old High School dates from 1856. The 1887–90 extension, by James Marjoribanks MacLaren, to the earlier school includes a tower with a revolving copper-domed observatory at the top of the building, which retains its original Newtonian telescope. The observatory was gifted by Sir Henry Campbell-Bannerman. The school was converted into the Stirling Highland Hotel in 1990.

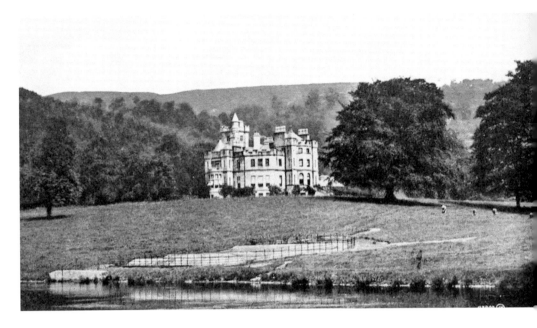

Airthrey Castle

Records of the Airthrey estate date back to the twelfth century, and over the centuries it passed through the ownership of a number of noble families. In 1759, the estate was sold to the Haldane family, who commissioned the landscaping of the grounds by Thomas White and a new house by Robert Adam, which, despite later additions, still forms the core of the present building. The castle functioned as a maternity hospital during the Second World War and continued in this use until 1969, allowing a number of locals of a certain age to claim that they were born in a castle. The Airthrey estate now forms the campus of the University of Stirling.

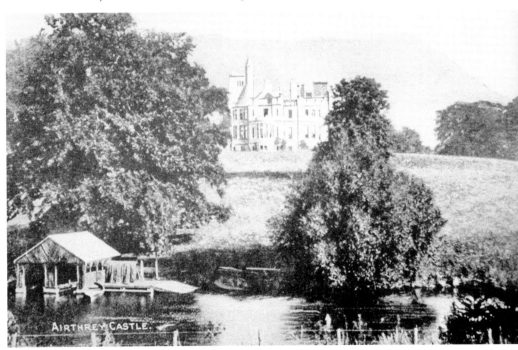

SECTION 5

THE VALLEY CEMETERY AND CHURCH OF THE HOLY RUDE

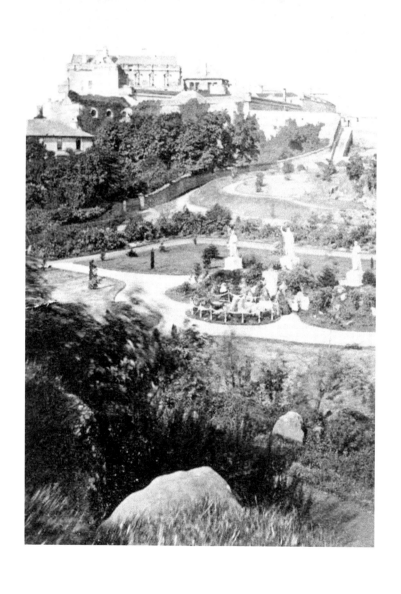

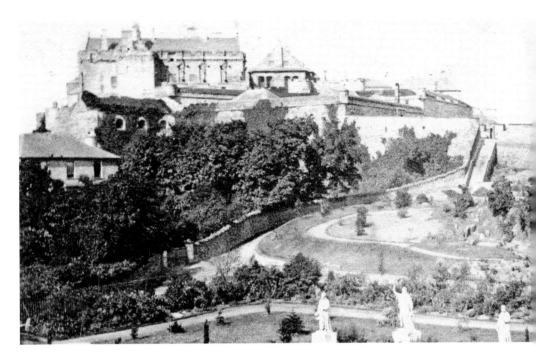

Valley Cemetery
We know of no sweeter cemetery than that of Stirling.

William Wordsworth

Immediately beneath the castle esplanade to the south, lies the town cemetery. The scene, while full of impressive loveliness, is also very deceptive. From the natural beauty of the situation, and the exquisite skill with which statuary, shrubbery, and rockeries are arranged throughout the burial garden, it is hard to be convinced that what is seen is for the most part artificial.

The History of Stirlingshire, William Nimmo (1880)

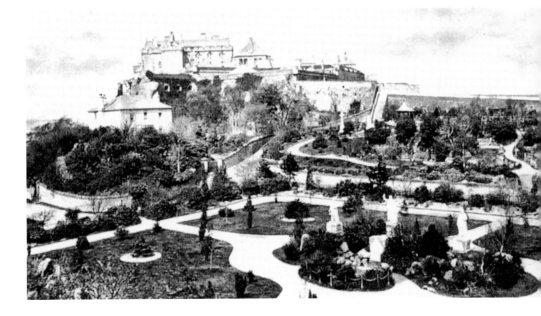

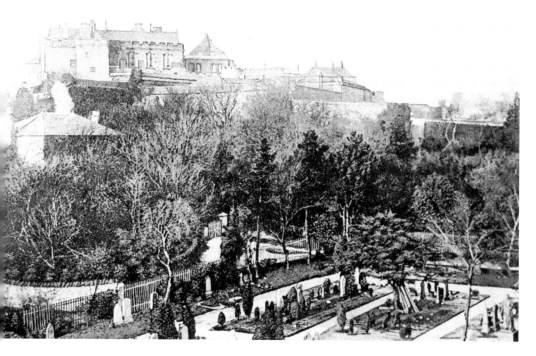

Valley Cemetery

The Valley Cemetery was laid out in 1857–58 by Peddie and Kinnear as an extension to the kirkyard of the Church of the Holy Rude. It was previously an important open space between the castle and the town where jousting and public events, such as horse markets, were held. The rocky outcrop, which overlooks the cemetery, is known as the Ladies' Rock and formed an elevated vantage point for the ladies of the court to view royal tournaments. It continues to provide panoramic views across to the Trossachs and Ben Lomond.

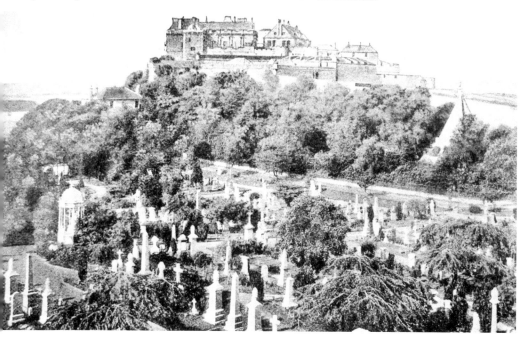

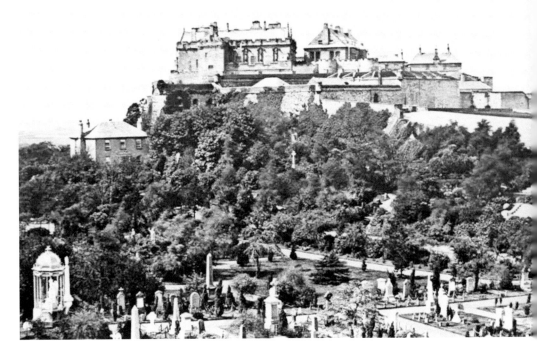

Valley Cemetery

The creation of the Valley Cemetery was due to Revd Charles Rogers. Rogers was chaplain at the castle and a town councillor. He was said to have had a degree of statue mania, being responsible for the Wee Wallace on the Athenaeum, Bruce on the esplanade, the Martyrs' Monument and the statues of the heroes of the Scottish Presbyterian Reformation (John Knox, Andrew Melville, Alexander Henderson, James Renwick, James Guthrie, and Ebenezer Erskine) in the Valley Cemetery. The cemetery was largely funded by William Drummond (1793–1868).

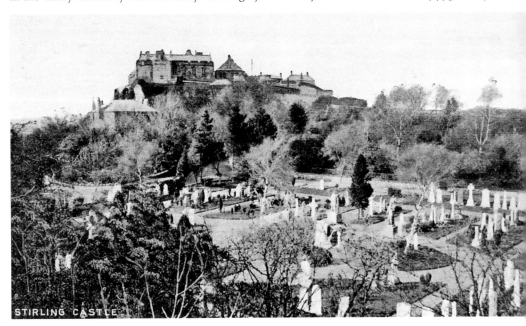

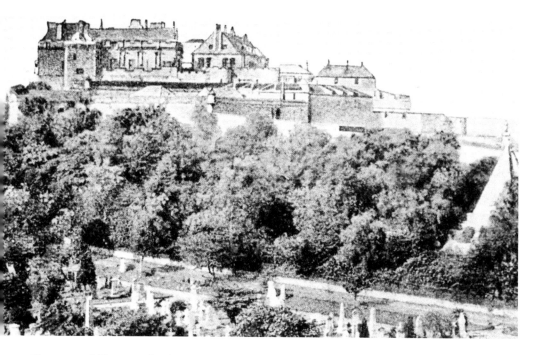

Drummond Pleasure Garden

As the name suggests, William Drummond (1793–1868), Stirling's prolific benefactor, was responsible for the Pleasure Ground, which is the setting for the Star Pyramid. Drummond was a prominent Stirling businessman who is described as a 'seedsman, evangelist and an ardent Presbyterian'. He was the brother of Peter Drummond (1799–1877), the founder of Stirling's Drummond Tract Enterprise. The Pleasure Ground was laid out in 1863 as a setting for the Star Pyramid, the largest pyramid structure in Scotland and dedicated to the cause of the Presbyterian Church in Scotland. The pyramid form was popular at the time as a symbol of stability and endurance.

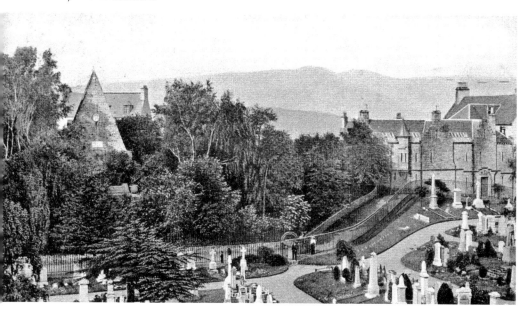

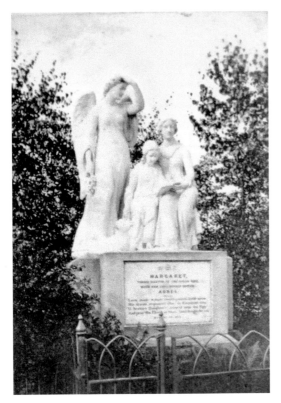

The Virgin Martyrs' Monument

The Virgin Martyrs' Monument in the Valley Cemetery depicts an angel watching over two young girls, with the older of the two reading the Bible to the other. It commemorates two young Wigtownshire girls, Margaret and Agnes Wilson, who were sentenced to death by drowning in 1685. Margaret and Agnes were Covenanters and refused to swear an oath of allegiance to Charles II, which amounted to them committing high treason. Agnes, who was in her early teens, had her sentence commuted. However, Margaret, who was aged eighteen, along with an elderly neighbour, Margaret McLaughlin, were tied to stakes on 11 May 1685 in the Solway Firth and left to drown in the incoming tide. The monument was erected in 1859 and the cupola was added in 1867. The sculptor was Alexander Handyside Ritchie (1804–70) and the cupola was by John Rochhead, the architect of the National Wallace Monument.

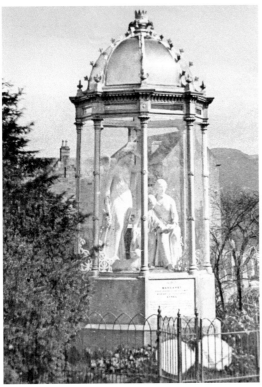

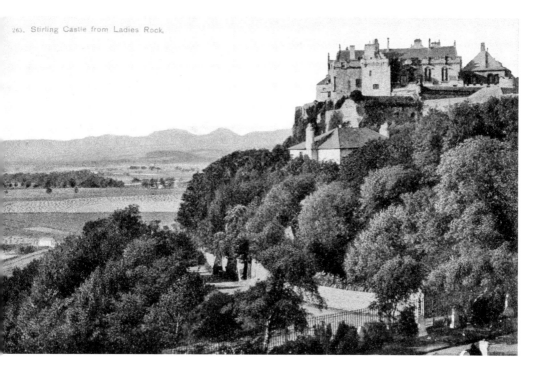

263. Stirling Castle from Ladies Rock.

Ladies' Rock

Tradition has it that the raised rocky outcrop to the south of the Valley Cemetery was a vantage point from which the ladies of the court could view events, such as jousting tournaments, in the Kings Park. The rock also offers outstanding views of the castle, the Valley Cemetery and the surrounding countryside.

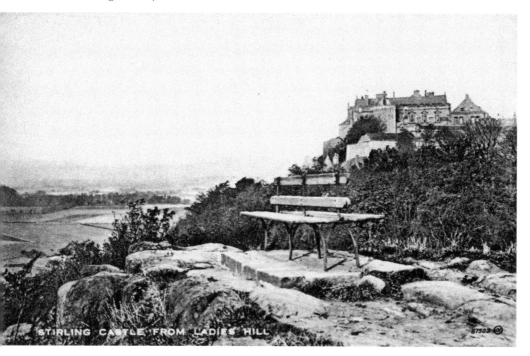

STIRLING CASTLE FROM LADIES HILL

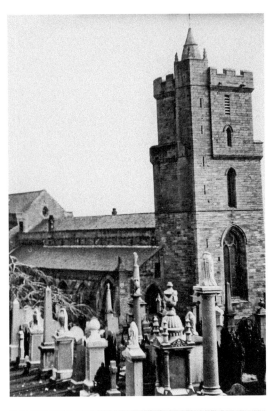

The Parish Church of the Holy Rude, Castle Wynd

The Church of the Holy Rude is the original parish church of Stirling and one of Scotland's most important medieval buildings. A church was first established on the site in 1129 during the reign of David I (1124–53). Between 1371 and 1390, Robert II dedicated an altar to the Holy Rude (Holy Cross) within the church and it became known as such. The original church was destroyed, along with much of Stirling, in a devastating fire in 1405. The new church with its distinctive square belfry tower was rebuilt from 1414.

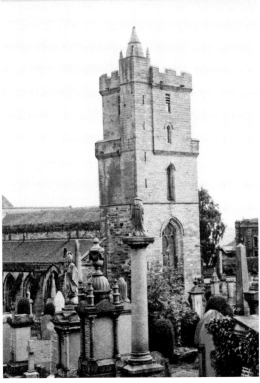

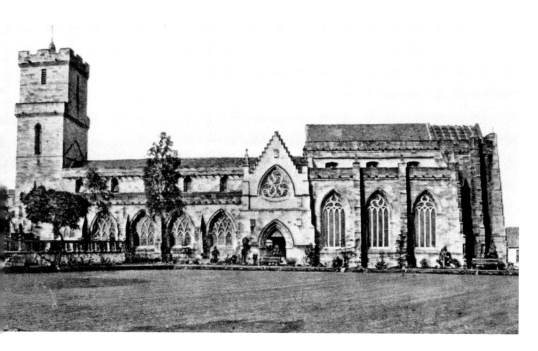

The Parish Church of the Holy Rude, Castle Wynd

The church is closely associated with the monarchy. It was the venue for the coronation of Mary, Queen of Scots on 9 September 1543 and the hastily arranged coronation of her son, the infant James VI, on 29 July 1567, after his mother was forced to abdicate. It is said to be the only existing church in the United Kingdom, apart from Westminster Abbey, to have hosted a coronation. The walls of the church show sign of musket shot and cannon fire from battles around the castle.

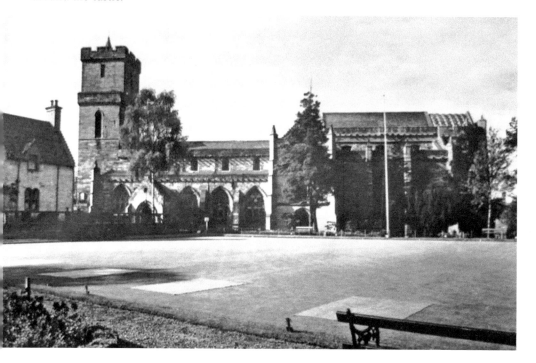

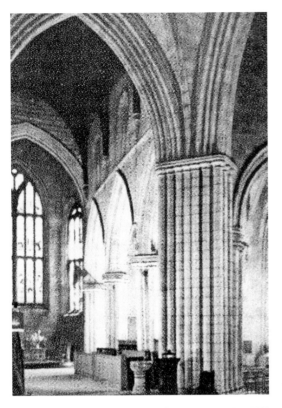

The Parish Church of the Holy Rude,
Castle Wynd
In the medieval period the Scottish
burghs generally contained only one
parish church, which was central to the
life of the community. It was accordingly
of significant scale and splendour, with
chapels and adornments added by the
trade guilds and private individuals. The
church was restored in the late 1930s,
when the partition that had divided the
building into two places of worship was
removed.

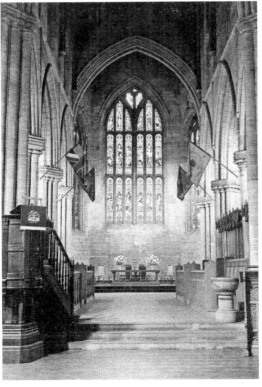

SECTION 6
STIRLING BRIDGE

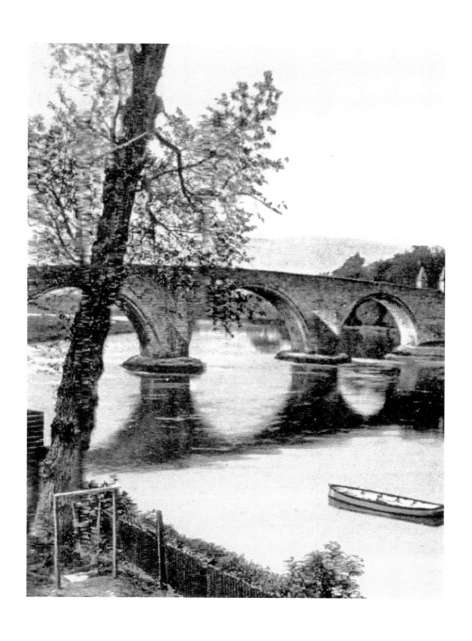

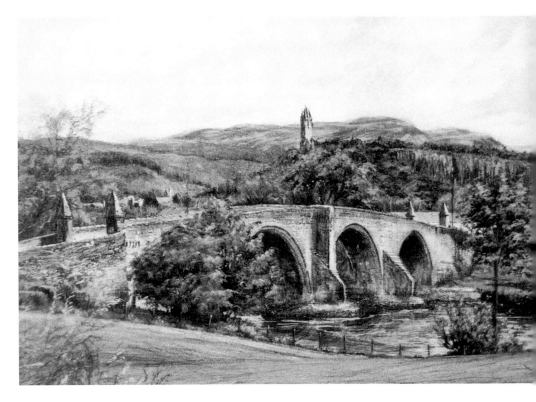

Stirling Old Bridge

The Old Bridge, an ancient relic, much admired for its spacious and lofty arches; venerable from its antiquity; beautiful from its situation; and interesting in the highest degree on account of its celebrity in Scottish history.

A New Description of the Town and Castle of Stirling (1835)

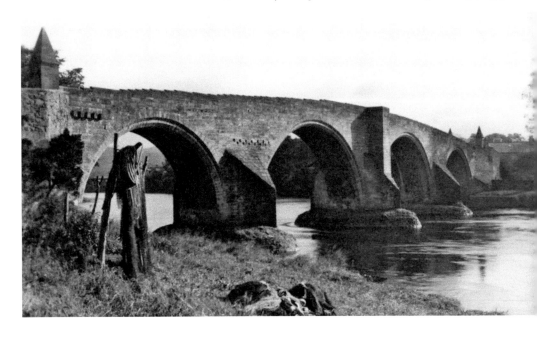

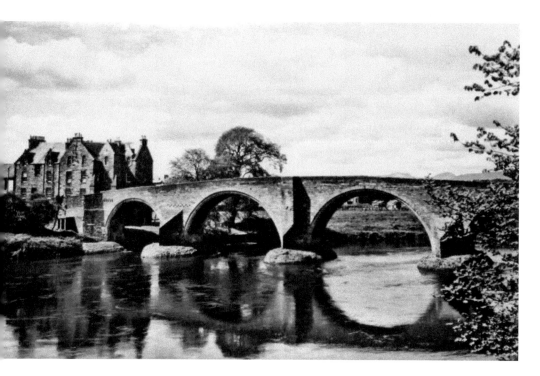

Stirling Old Bridge

Stirling owes much of its early prominence and prosperity to the beautiful and picturesque Stirling Old Bridge, which for four centuries was the only roadway over the Forth and the most strategically important river crossing in Scotland. The bridge was built in the early part of the fifteenth century and its construction is ascribed to Robert Duke of Albany, Earl of Fife and Menteith. The bridge, protected by the castle, is the main reason for Stirling's existence. A bridge, probably in timber, existed at least as early as the thirteenth century.

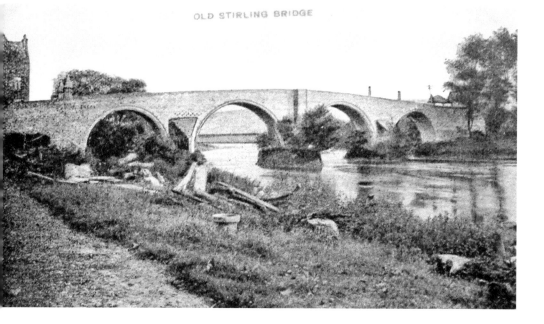

OLD STIRLING BRIDGE

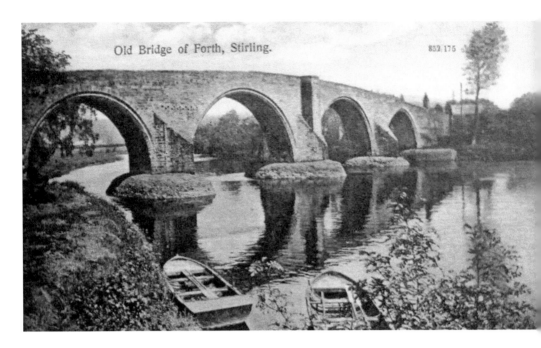

Old Bridge of Forth, Stirling.

Stirling Old Bridge

The old bridge is by far the most noted structure of the kind in Scotland. It is the first erection of the sort which occurs on the Forth; and was, till lately, almost the only access for wheeled carriages from the south into the north of Scotland. Its age is unknown. The first mention made of it is in 1571, when Archbishop Hamilton was hanged on it by the king's faction, under the regent Lennox. General Blackeney, the governor of the castle, caused the south arch to be destroyed in 1745, in order to intercept the Highlanders.

The Tourist's Companion Through Stirling, John Forbes (1848)

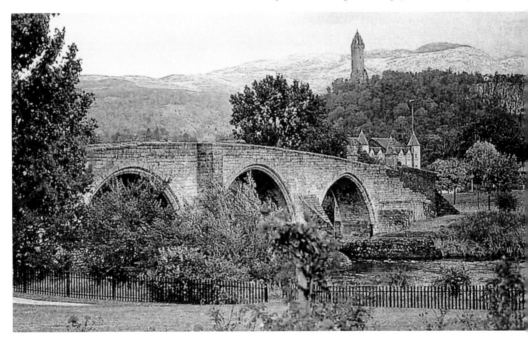

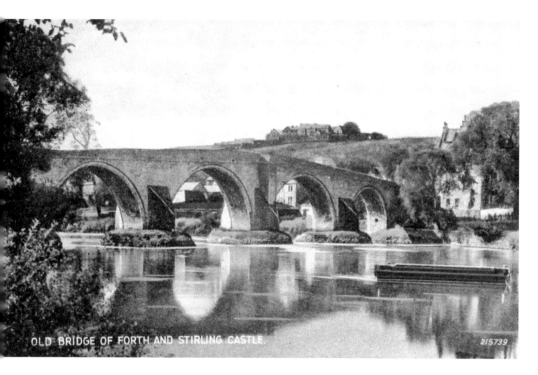

OLD BRIDGE OF FORTH AND STIRLING CASTLE. 2/5739

Stirling Old Bridge

The roadway of the bridge is supported on four semicircular arches, none of which has the same width of span. The bridge previously had massive towers with arched gateways at each end. The south archway was removed when the arch of the bridge was cut (in 1745) during the Jacobite rebellion to prevent the Highlanders from crossing into Stirling, and the north archway was taken down in 1749. The bridge was closed to vehicles in 1834.

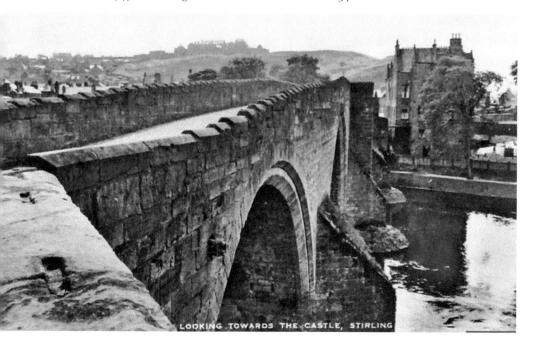

LOOKING TOWARDS THE CASTLE, STIRLING

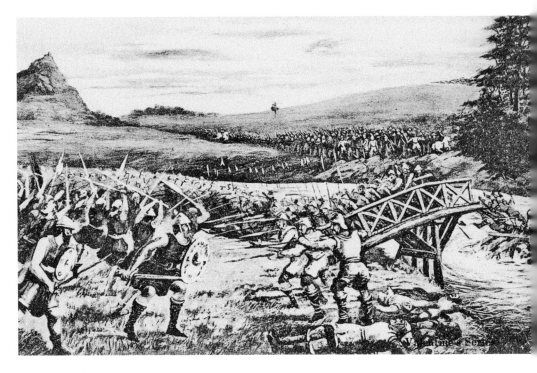

Battle of Stirling Bridge

The old wooden bridge at Stirling, which was central to the Battle of Stirling Bridge on 11 September 1297, was located around 180 yards upstream from Stirling Old Bridge. The battle was a famous victory for Scotland's national hero William Wallace during the First War of Scottish Independence. The key to the Scottish victory was the tightly packed schiltrons (circular formations of men with long spears), which proved impenetrable to the English knights.

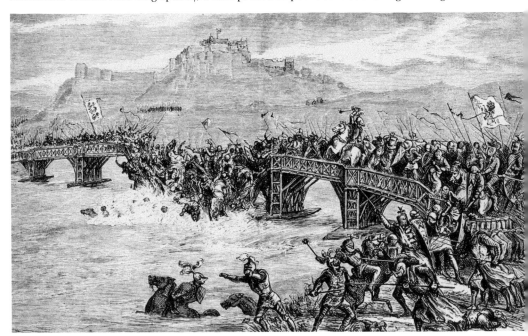

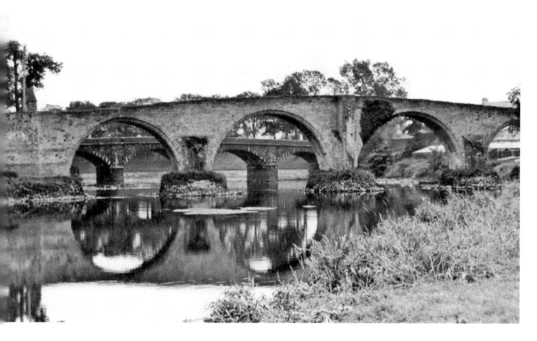

Stirling New Bridge

At a meeting held in Stirling in October, 1826 it was proposed that a new bridge should be built, as the old one was of little use for traffic. The bridge was afterwards contracted for by Mr Kenneth Mathieson, at a cost of £13,368, and completed by Whitsunday, 1832.

Old Faces, Old Places and Old Stories of Stirling, William Drysdale (1899)

Stirling New Bridge is just downstream from the Old Bridge. It was opened in 1833 and was designed by Robert Stevenson (1772–1850), one of Scotland's most eminent civil engineers, renowned designer of lighthouses and the grandfather of Robert Louis Stevenson. An alternative design by Thomas Telford was rejected.

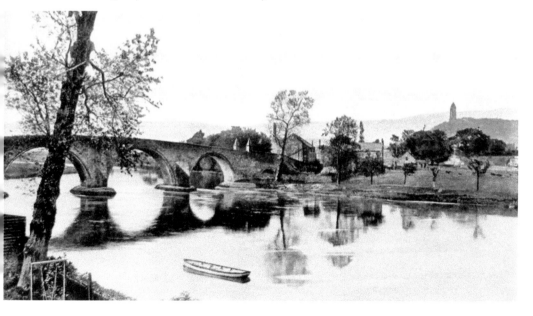

SECTION 7

NATIONAL WALLACE MONUMENT

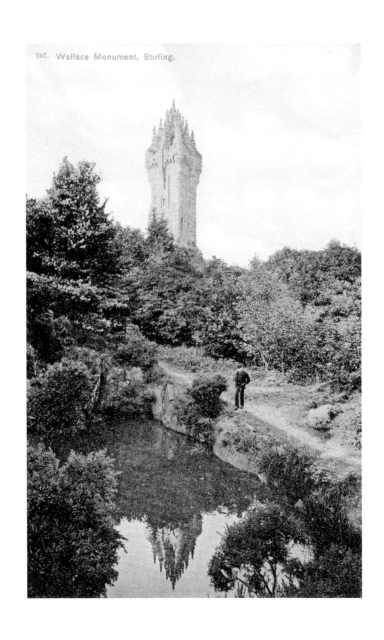

267. Wallace Monument, Stirling.

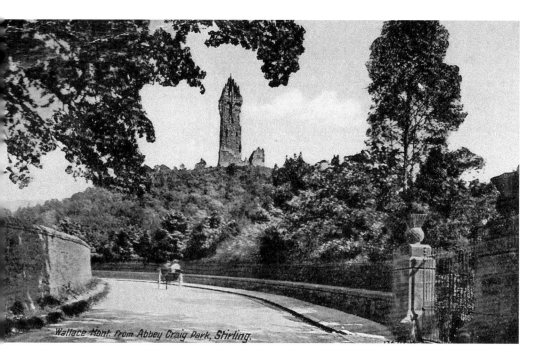

Wallace Mont. from Abbey Craig Park, Stirling.

The National Wallace Monument, Abbey Craig

In our estimation it would be impossible to find a situation in all respects more suited for a national monument, or better adapted for a memorial cairn to the national hero. Abbey Craig is geographically in the centre of Scotland; it is likewise the centre of the Scottish battle-ground for civil and religious liberty. It overlooks the field of Stirling Bridge, where Wallace obtained his greatest victory; and the monument will surmount the spot where he is believed to have stood while surveying the legions of England crossing the bridge, in their path to destruction.

Extract from brochure on opening of the National Wallace Monument, Revd Dr Rogers (1861)

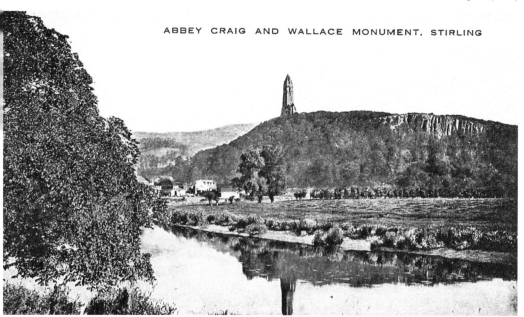

ABBEY CRAIG AND WALLACE MONUMENT, STIRLING

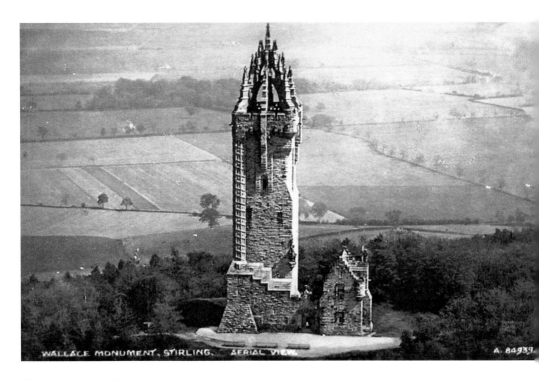

WALLACE MONUMENT, STIRLING. AERIAL VIEW. A. 84939.

The National Wallace Monument, Abbey Craig

It took a long time for a fitting memorial to be built to Wallace, but when this great landmark was built its grandeur more than compensated for the delay. From the 1820s onwards proposals had been made for different sites in both Edinburgh and Glasgow for a monument to Wallace. In 1859 the site at Abbey Craig was agreed. A fundraising campaign was established, and a national competition organised for a suitable design.

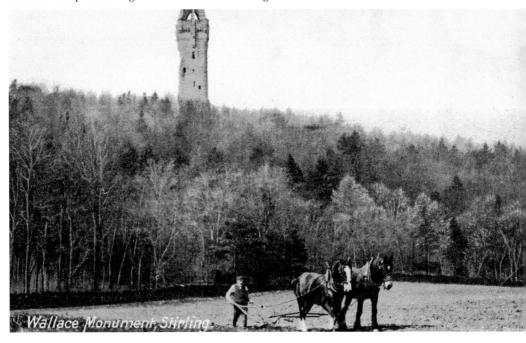

Wallace Monument, Stirling.

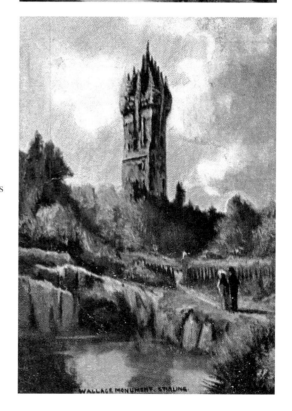

National Wallace Monument, Abbey Craig

John T. Rochead's (1814–78) soaring Scottish Baronial tower surmounted by an imperial crown was the winning entry. The Scottish Baronial style was a nineteenth-century revival of Scottish architectural forms, taking its inspiration from the buildings of the Scottish Renaissance. It is typified by the incorporation of architectural features associated with Scottish castles such as crenellations, turreted bartizans, oriels and the use of massive hewn stone. One of the motivations behind its development was a revived interest in the exploration of national identity. It was, therefore, considered the architectural style that was most appropriate to celebrate one of Scotland's national heroes.

WALLACE MONUMENT. STIRLING.

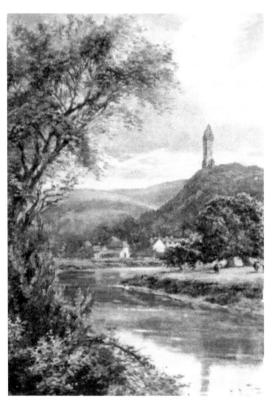

National Wallace Monument, Abbey Craig

The foundation stone of the monument was laid by the Duke of Athole, Grand Master Mason, among much ceremony and in front of a crowd estimated at 80,000 on 24 June 1861. The monument opened on 11 September 1869, the 572nd anniversary of Wallace's great victory at Stirling Bridge.

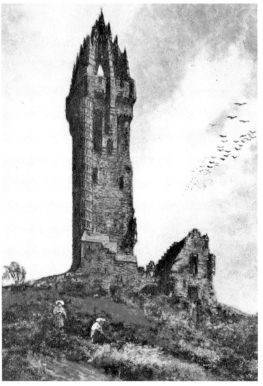

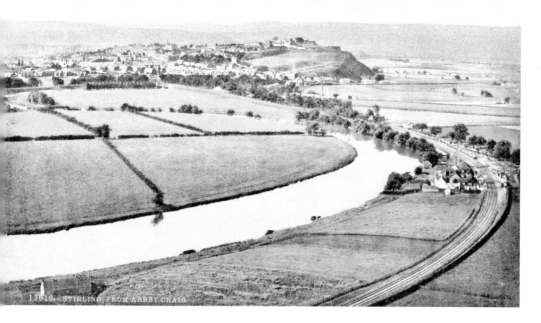

View from Abbey Craig

Here we feel elevated, as if by enchantment, in the midst of a fairy scene, a panorama of the most ennobling character. Around is a level plain, watered by the silvery courses of the river Forth and guarded at almost every point by stupendous mountains. For miles on every side, everything is picturesque, beautiful, or sublime, there being not one single feature to mar the loveliness of the landscape or detract from the poetry of the scene.

A Week at Bridge of Allan, Revd Dr Rogers (1853)

Stirling Castle from Abbey Craig

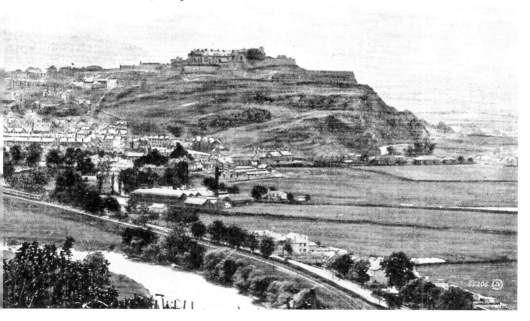

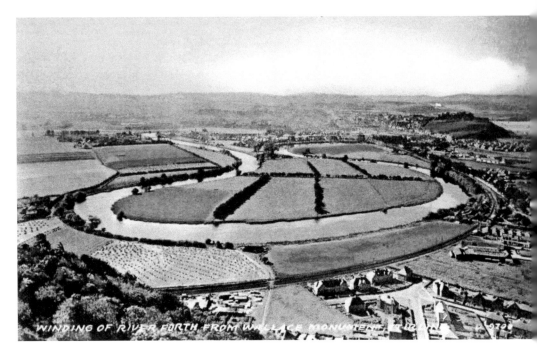

WINDING OF RIVER FORTH FROM WALLACE MONUMENT STIRLING

View from Abbey Craig

There is a spectacular panorama from Abbey Craig towards Stirling, with the 'silvery Forth reposing, serpent like, in the centre of the plain'. The fertile soil in the meanders or links of the Forth at Stirling gave rise to the old rhyme: 'A crook o' the Forth is worth an Earldom o' the north.'

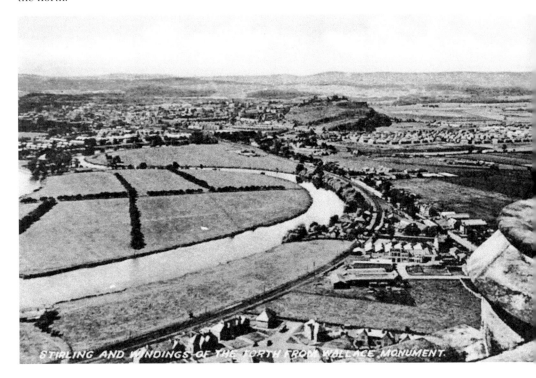

STIRLING AND WINDINGS OF THE FORTH FROM WALLACE MONUMENT.

SECTION 8

AROUND STIRLING

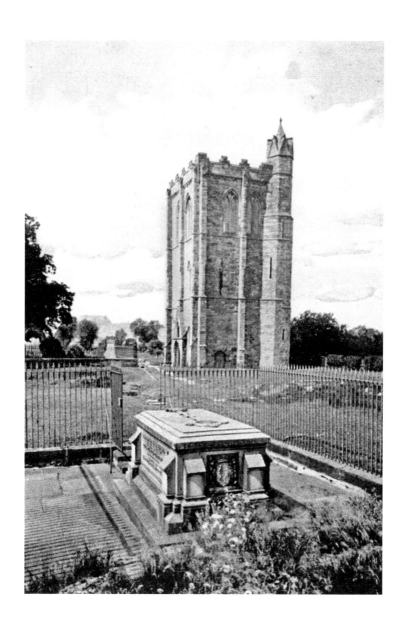

Cambuskenneth Ferry

The ferry boat connection between Stirling and Cambuskenneth dates back centuries. The patrons of Cowane's Hospital ran the ferry between 1709 and 1935. The loop of the Forth at Cambuskenneth was particularly fertile and the area was famed for its fruit production. The ferry was much in demand during the Berry Fair, when Stirling residents would make the crossing to buy the produce. The operation of the ferry on the Sabbath outraged Peter Drummond (1799–1877), and he started a leaflet campaign against the blasphemous act in 1848. This led to Drummond establishing the Stirling Tract Enterprise, a major religious publishing business.

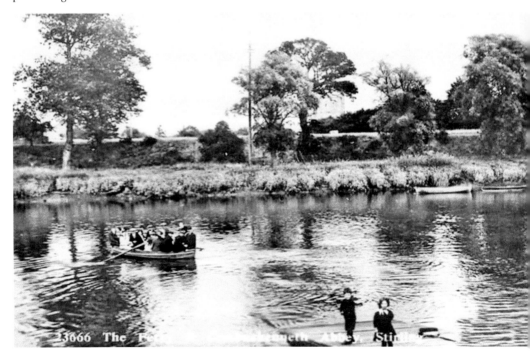

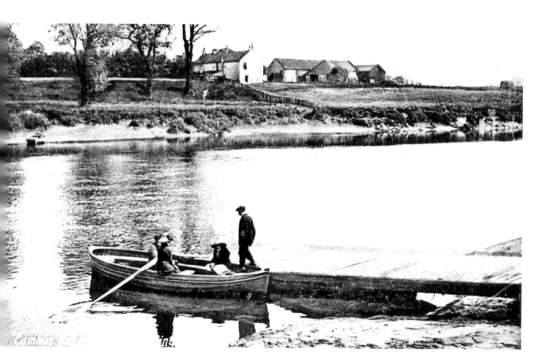

Cambuskenneth Footbridge and the Last Ferry Boat

Proposals to replace the Cambuskenneth Ferry with a bridge were discussed from the early part of the nineteenth century and rumbled on into the early twentieth century. In 1930, Cowane's Hospital gave notice of the intention to discontinue the ferry service, since it was not obliged to supply one and derived no profit from it. There were also complaints that the ferry was unsafe and inconvenient. This spurred on the authorities and the opening of the new footbridge on 23 October 1935 marked the end of the ferry.

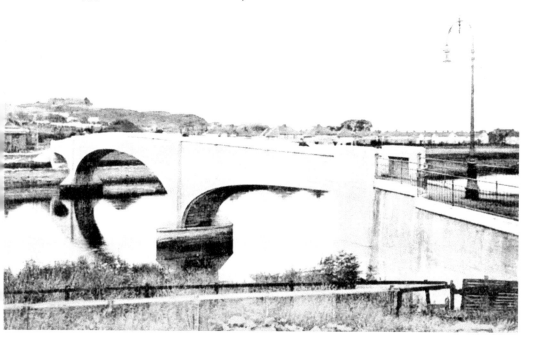

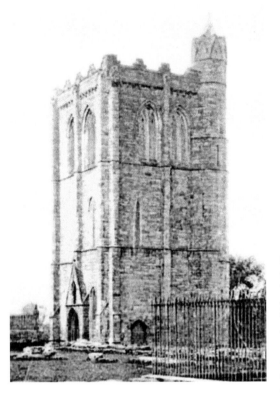

Cambuskenneth Abbey

Cambuskenneth Abbey was established by David I in 1147 for canons brought from Aroise Abbey as a dedication to the Virgin Mary. It was originally known as the Abbey of St Mary or the Abbey of Stirling. It was one of the wealthiest and most important abbeys in Scotland due to its royal connections and proximity to Stirling Castle. At its height the abbey comprised an extensive complex of buildings. Its closeness to Stirling Castle put it in the way of attack during the Wars of Independence – in 1383 it was largely destroyed by the army of Richard III – and it was rebuilt during the early 1400s. It was also the scene of several significant historic events: in 1314 Robert I held a Parliament at the abbey following the Battle of Bannockburn.

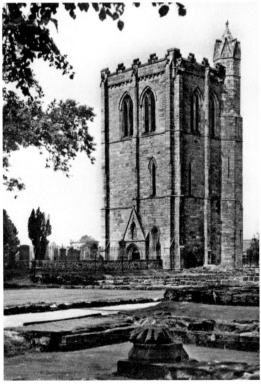

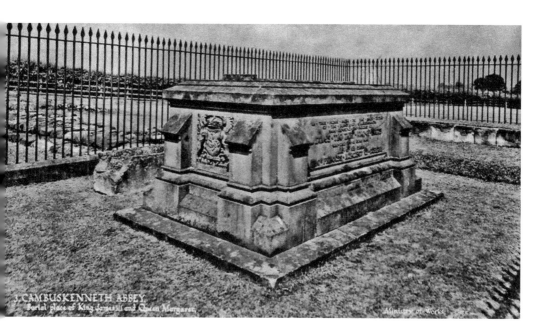

CAMBUSKENNETH ABBEY.
Burial place of King James III and Queen Margaret.

Ministry of Works

Cambuskenneth Abbey

The abbey was abandoned in 1559 during the Scottish Reformation, with stone removed for building work in the town, including Mar's Wark. The abbey is reduced to its foundations except for the dramatic three-storey square bell tower, which dates from 1300 and is considered to be the finest surviving medieval bell tower in Scotland. The elaborate tomb on the site marks the last resting place of James III, who was murdered near Bannockburn after fleeing the Battle of Sauchieburn on 11 June 1488. He was interred in front of the high altar of the abbey church alongside his queen, Margaret of Denmark, who died in 1486. The tomb was paid for by Queen Victoria following the discovery, in 1865, of two coffins that were presumed to be those of the royal couple.

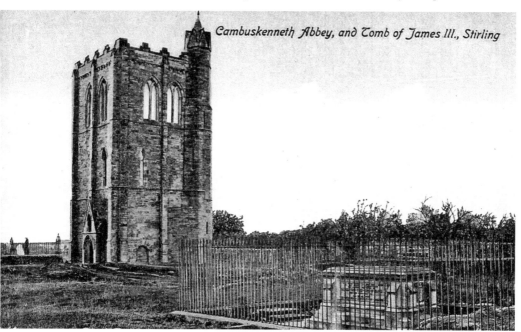

Cambuskenneth Abbey, and Tomb of James III., Stirling

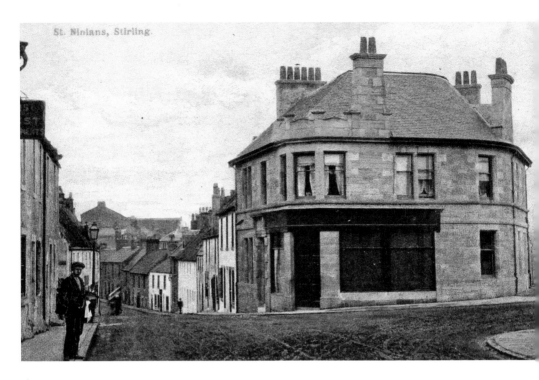

St Ninians

St Ninians is an ancient village approximately a mile south of the centre of Stirling. St Ninians prospered in the eighteenth and nineteenth centuries based on local weaving, mining and nail making. After the Second World War, large-scale demolition and road building resulted in the loss of many historic buildings in the village.

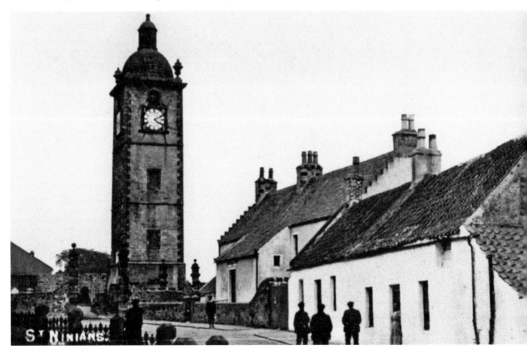

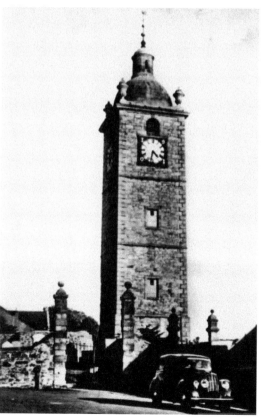

St Ninians Tower, Kirk Wynd

There are records of a church on the site in St Ninians from as early as 1150. The church was extensively altered and rebuilt in the early eighteenth century and the classically influenced landmark tower was built in 1734. However, the church was mainly destroyed on 1 January 1746 when it was blown up by the retreating Jacobite army, which had been using the building as a gunpowder magazine. Only the tower and fragments of the church, a fifteenth-century pillar from the original nave and the sixteenth-century chancel survived the blast. A new parish church was built in 1751 to the east.

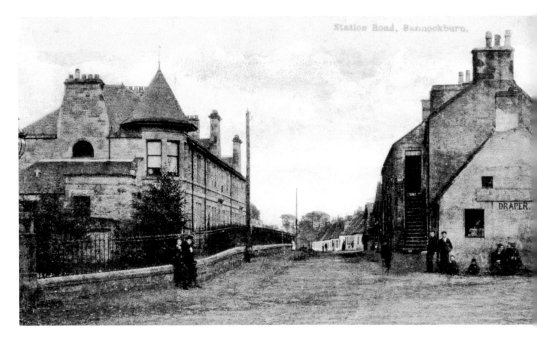

Bannockburn

Bannockburn, a village situated on both sides (but chiefly the east side) of the rivulet called Bannockburn, which here runs through a glen, and after a course of a few miles drops into the Forth on its south bank, at a place called Manor. The village of Bannockburn is one of the most industrious and thriving villages in Scotland. For many years its inhabitants have devoted themselves to the manufacture of tartan cloths, and such peculiar woollen fabrics, as well as carpets of an excellent quality, and other articles in the woollen line. A considerable trade is here carried on also in the tanning of leather. It has two annual fairs.

The Gazetteer of Scotland, Robert Chambers (1836)

Old Bridge, Bannockburn.

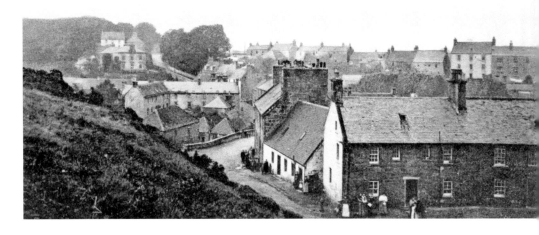

90

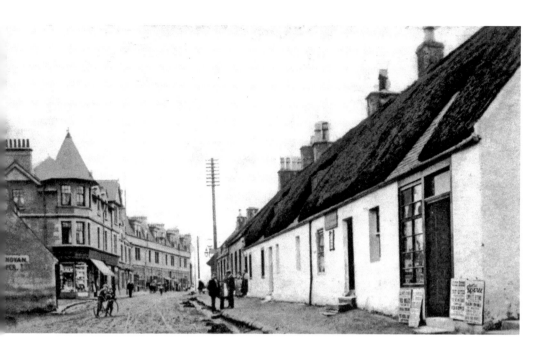

Bannockburn

Bannockburn, immediately south of Stirling, takes its name from the Bannock ('White') Burn that runs through the town. The town, with its access to water power, nearby grazing for sheep and proximity to the emergent markets in central Scotland, from the mid-eighteenth century developed from a small ancient settlement to a bustling centre for tartan and carpet weaving. The town continued to thrive with the opening of the Bannockburn Colliery at Cowie in the 1890s. Bannockburn station opened in 1848 as a stop on the Scottish Central Railway and closed in 1950.

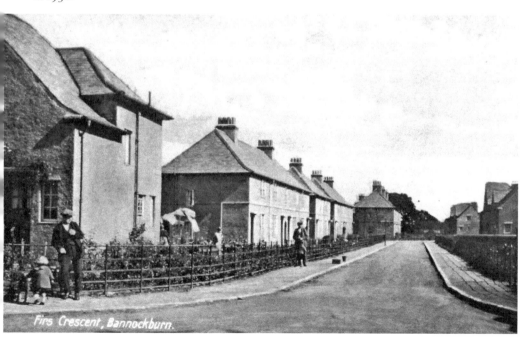

Firs Crescent, Bannockburn.

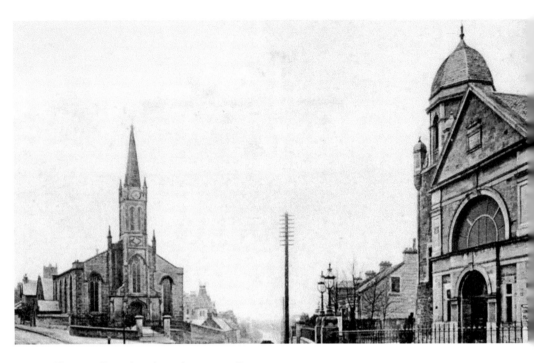

Bannockburn, Allan Church and Town Hall

The Allan Church dates from 1837–38. It takes its name from Revd James Allan, who was ordained as the minister in 1888 and an influential figure in the town. Bannockburn Town Hall, with its distinctive domed turret, opened on 25 May 1888. It was demolished in the mid-1970s and is now the site of Memorial Park.

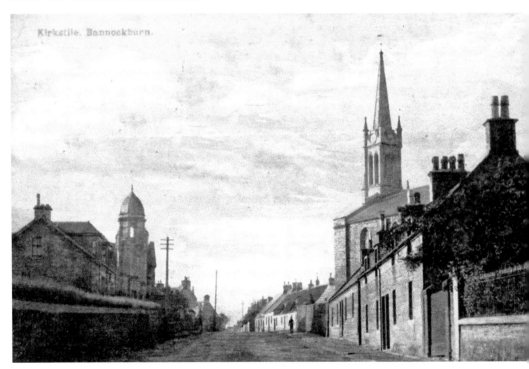

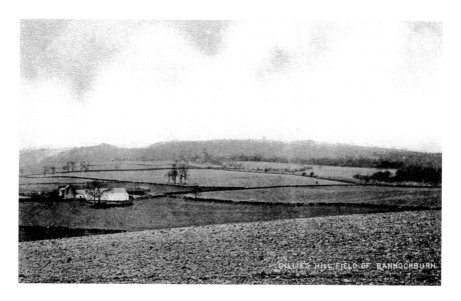

Battle of Bannockburn

King Robert was ill mounted, carrying a battle-axe, and, on his helmet, wearing, for distinction, a crown. Thus externally distinguished, he rode before the lines, when an English knight, Sir Henry de Boun, came up to him, to engage in single combat, expecting, by this act of chivalry, to end the contest and gain immortal fame. But the enterprising champion, having missed his blow, was instantly struck dead by the king, the handle of whose axe was broken with the violence of the shock.

History of Stirlingshire, William Nimmo (1880)

Bruce and de Bohun, were fightin' for the croon
Bruce taen his battle-axe and knocked de Bohun doon.

The Battle of Bannockburn on 23 and 24 June 1314 was a famous victory for the Scots against the vastly superior invading army of Edward II. The victory secured Robert the Bruce's reputation as one of the great heroes of Scottish history and Scotland's future as an independent nation.

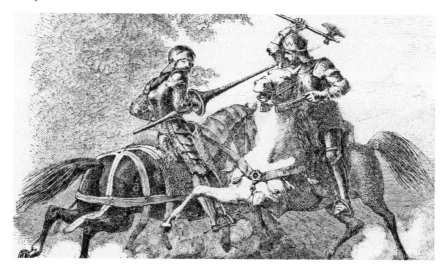

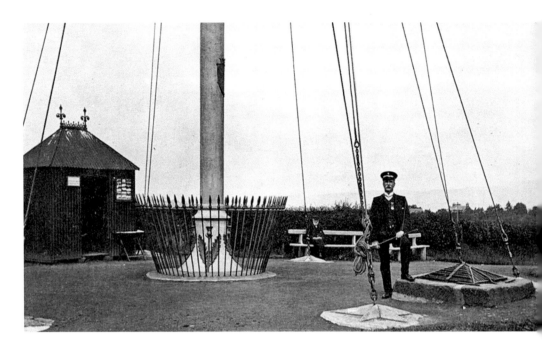

The Borestone

Legend has it that the Scottish standard at Bannockburn was raised on a circular millstone known as 'the Borestone'. It became an emblem of national pride for many Scots and a target for early memento hunters, who chipped off parts of the stone as keepsakes. The stone was later protected by an iron grille and, in 2014, the remaining two pieces were moved inside the new visitor centre. The original site of the Borestone is marked by a bronze B-shaped plaque. The flagpole was erected in 1870 by the Dumbarton Loyal Dixon Lodge of the Independent Order of Oddfellows.

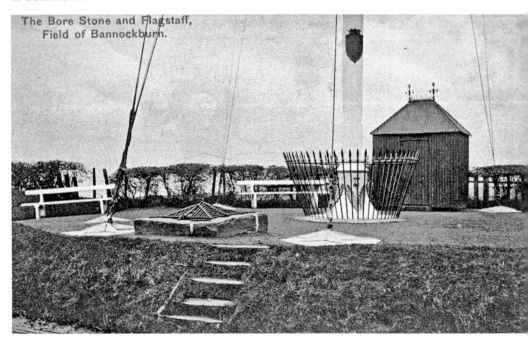

The Bore Stone and Flagstaff, Field of Bannockburn.

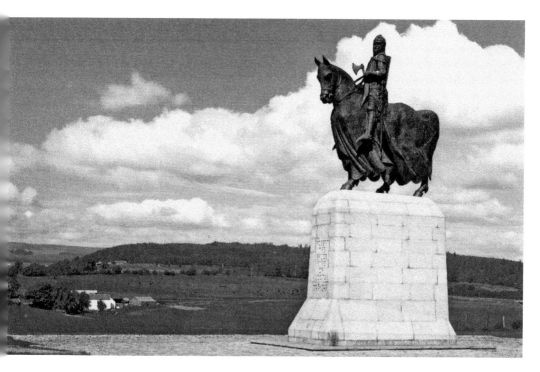

Bruce Statue, Bannockburn

The bronze equestrian statue of Robert the Bruce at Bannockburn, by the sculptor Charles d'Orville Pilkington Jackson, was unveiled in 1964 by HM the Queen on the 650th anniversary of the Battle of Bannockburn. The innovative new Battle of Bannockburn Visitor Centre opened on 1 March 2014, in the 700th anniversary year of the battle.

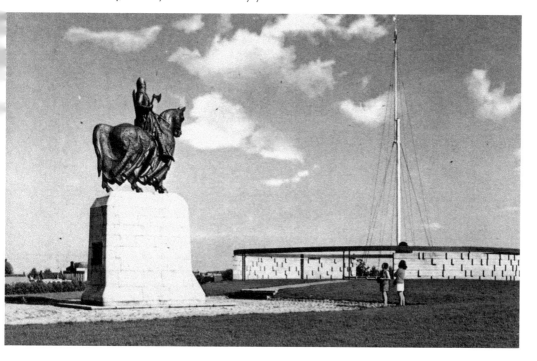

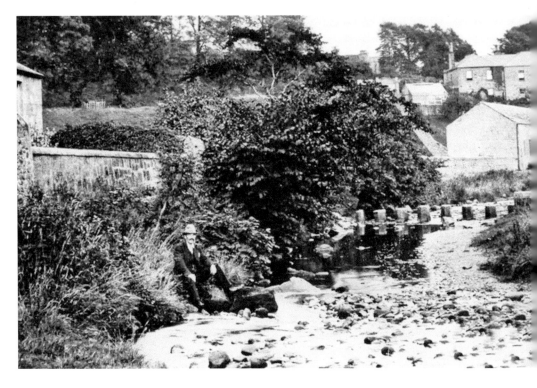

The Stepping Stones, Bannockburn

The stepping stones were located near a mill dam that served factories to the west of Bannockburn. They supplemented footbridges in the area and would have been a convenient, but somewhat precarious, way to cross the river.

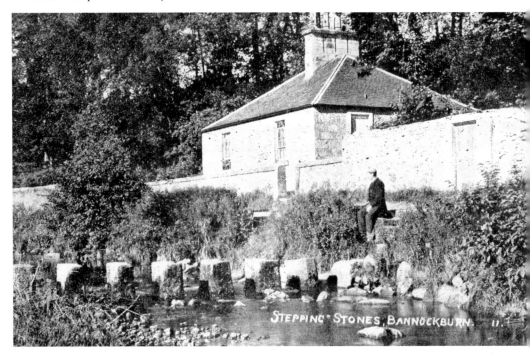